RUSKIN

RUSKIN

QUENTIN BELL

1978
THE HOGARTH PRESS
LONDON

Published by
The Hogarth Press Ltd
40 William IV Street
London WC2N 4DG

*

Clarke, Irwin & Co. Ltd
Toronto

First published 1963
This edition published 1978

British Library Cataloguing in Publication Data

Bell, Quentin
 Ruskin. – 2nd ed
 1. Ruskin, John 2. Authors, English –
 19th century – Biography
 828'.8'09 PR5263

 ISBN 0–7012–0459–1

© Quentin Bell 1963 and 1978

Printed in Great Britain by
Redwood Burn Limited
Trowbridge & Esher

CONTENTS

ABBREVIATED TITLES
BY WHICH RUSKIN'S WORKS
ARE CITED IN REFERENCES

Volume and page references are to the "Library Edition" of Cook and Wedderburn. But where it seems helpful the volume as first published is indicated in arabic figures.

Thus M.P. (Vol 3), V.45
means that the quotation is taken from the Third Volume of *Modern Painters* but that it will be found on page 45 of the Fifth Volume of the "Library Edition".

F.C.	Fors Clavigera
M.P.	Modern Painters
P.	Præterita
S.L.	Sesame and Lilies
S.L.A.	The Seven Lamps of Architecture
S.V.	The Stones of Venice

PREFACE

This book appeared originally as one of a series entitled *Writers and Critics*; the editor of that series was Professor Norman A. Jeffares and it was he who persuaded me to undertake this work; I have many reasons for being grateful to him but in this matter he went beyond even *his* usual benevolence. He gave me a treat. I have seldom written anything with greater pleasure and there is no work by me that I can take from the bookshelf and peruse with less of shame or of regret, there are here few passages that I am tempted to rewrite and in fact there is a good deal that I can read with positive pleasure.

But the fact that I was able without much pain and with positive enjoyment to produce a book that I can now consider without dismay was by no means my only profit from that transaction. Some ten years earlier I had, for a now unbelievably small sum, purchased the complete set of Wedderburn and Cook's excellently well edited *Library Edition* of Ruskin. Those thirty nine red leather-bound volumes sat on my shelves looking very fine and making me look academically respectable; but I must admit that it was their bindings that I knew best. Confronted by the task of writing about him I saw that now at last I must actually read Ruskin. And so, feeling like one who wades out into the cold waters of the Channel with France as his destination, I took the plunge and for twelve months I read Ruskin and nothing else. As I went on I found the task becoming more and more enjoyable so that, emerging at last at the end of Volume 38, I had a sense, not only of floundering ashore at Cap Griz Nez, but of sorrow at the loss of

so charming a companion. Ruskin, when once you have come to terms with him is indeed extremely readable and it is pleasant at the end to discover his masterpiece *Praeterita*. Also, he is very instructive. He taught me a great deal about two important subjects: the use of English and the nature of art criticism.

Ruskin, early decorated, luxuriant Ruskin, complete with crockets and crenellations is I am convinced, a model which all those of us who are learning to write should study, imitate and learn to love. I say this despite the fact that in doing so I shall find that, amongst teachers of English eyebrows will be raised, lips will probably be pursed and a variety of clucking noises will be clearly audible. 'What', you will say: 'is that gold and purple prose that cloying sweetness of language to be considered wholesome fare for the young? We live in the late Twentieth Century and what style could possibly be less appropriate for us than that of the eighteen forties? The suggestion is absurd, it is as though some girder-bending, concrete-mixing, polyvinylurinated art student were told to copy Bernini.'

This of course is just what such an art student ought to do (and in saying this I am looking straight at you Jane Doe and at you, Richard Roe, both of you now majoring in creative writing at the University of Labrador). Ruskin can help you, he cannot harm you. The authors who can do you a mischief are those whom you would naturally admire, those whose writings 'make sense' within the context of your own age, those who are still new and smart and popular and 'relevant'. These you copy at your peril for they are saying the kind of things that you want to say, in using their phrases you may be cozened into believing that they are your own, their style is so close to yours that yours may become infected by theirs. Then indeed

10

you may grow into a sedulous ape, a wind bag blown tight with the stale phrases of other people and then indeed you will be damned.

But the modern student who will never celebrate the glorious agonies of St Teresa, who will never be bothered by the question: how best are we to construct sheepfolds? will soon learn to look beyond those Ruskinian exclamations which at first may fill his timid twentieth century soul with confusion and alarm and he will find in the utterances of one who at first sight seems so alien, a science and a strength well worth his study. He will learn what amazing things may be done by the English Language when it is manipulated by strong and skilful hands.

At the risk of sounding immodest I would say that whatever positive virtues there may be in my own style whatever skills I have acquired and later used in the writing of biography are due to a year's immersion in Ruskin. And yet I do not think that my style is Ruskinian. He taught me that writing is not just a matter of exactitude, clarity and discretion, important though these qualities certainly are, writing is tremendous fun, it is a form of self-indulgence of positive pleasure a business in which one needs, not only a steering wheel and a good strong brake but a good strong engine as well.

Ruskin's value as an art critic is in a more complex way valuable, but as an example of what criticism can do, or to speak more plainly of what it ought to be, it is particularly enlightening because it is so often and so emphatically wrong headed.

All art critics must, from some points of view, be wrong. Ruskin is peculiar because, unlike most of us, he was demonstrably wrong and this because he manages so often to contradict himself.

11

The reader of Ruskin's work must, at some point, ask himself whether a person so absurdly and frequently at odds with himself can be a good critic. The answer, if one has any sensibility at all is clear: it does not matter in the least.

Observe the cautious Mr Sitworthy, he who knows just what to like and what not to like, what is 'coming in' and what is 'going out' in what jargon the hero of the moment is to be extolled, with what sneers yesterday's paragon is to be damned. Even the ingenious Mr Sitworthy cannot manage always to be right, for in that he reflects current opinion he must always admire modernity and although modernity is something that we can all achieve without effort it is a quality which cannot possibly endure. But supposing that Sitworthy by some miracle of ingenuity managed always to be in the right, that is to say always to be in agreement with the most influential part of the public, would he then be a 'better' critic than Ruskin?

If art criticism be a superior form of stock exchange prediction and the critic one who can tell what aesthetic stocks will rise and which will fall, what it is that we are to like next year and what will by then be hated, then indeed Sitworthy is the better man, for the art of the art critic must then be concerned with an assessment of other people's feelings or what will be their feelings. But when we read Ruskin we perceive that criticism is something different the feelings with which he is concerned are his own and, so long as he can make them perfectly known to us, it does not at all matter that by tomorrow they may have changed. The art critic needs two things: the power to feel intensely about works of art and the power rightly and fully to express his emotions, all the rest: the correct principles and theory and so on, all things that

Ruskin himself believed to be so important are in fact superfluous. All that matters is that burning sincerity and that golden voice.

Nor is it simply a question of art criticism, Ruskin wrote about a great many other things, political economy, geology, little girls, biology, and pretty well anything else that you may care to mention. Frequently the topics in themselves are boring, but Ruskin is never a bore. Frequently he talks nonsense and sometimes he saw the truth with startling clarity; but right or wrong his prose remains intensely alive, reading it we get to know him and, since he was a very great man, this is a considerable privilege. I hope that this book may help you to enjoy his company.

Chapter 1

THE CHAMPION OF TURNER

In 1836, when John Ruskin was seventeen, Augustus Welby Pugin published his *Contrasts*. One of the illustrations to this volume shows us an English city as it might have appeared in the fifteenth century. We view it from a slight eminence, and before us flows a broad river; seven Gothic arches carry a bridge across this stream, uniting a pleasantly wooded islet to the opposing shores. In the middle, upon the island, stands a fair chapel. At the further extremity is a fortified gateway and the town is entirely embraced by a battlemented wall. But it is the ecclesiastical rather than the temporal power which governs the scene; above the gabled dwelling houses rise a multitude of spires, various but not incongruous in style, united by one faith and one aesthetic purpose, their ascending lines repeated by the churches, shrines and abbeys which stand beyond the military confines of the town. Nothing that man has made offends the natural beauty bestowed by God, everything is subordinate to one common social obedience. A tranquil spirit of autocratic piety governs all.

In a second picture Pugin shows us the same town. The old bridge has been demolished; with it the island and its chapel; steamers blacken the girders of the new iron structure. Upon the site of the old walls stand warehouses, a pleasant church in the foreground is disfigured by unsightly iron chimney pots and is half obscured by a worldly modern parsonage. The shrines are demolished, the Gothic spires are lopped or left to ruin, the cheap new Italianate towers and

porticos of half a dozen dissenting tabernacles sprout assertively beneath a forest of factory chimneys through the smoke of which a great railway viaduct straddles the landscape. The jail, the gas works, the Socialist Hall of Science and the lunatic asylum complete the scene.

That was one view of what the free enterprise of the nineteenth century had achieved. The opposing view had been stated at an even earlier date by Macaulay in a criticism of Southey's *Colloquies*:

... when we compare our own condition with that of our ancestors, we think it clear that the advantages arising from the progress of civilisation have far more than counterbalanced the disadvantages arising from the progress of population. While our numbers have increased tenfold, our wealth has increased a hundredfold. Though there are so many more people to share the wealth now existing in the country than there were in the sixteenth century, it seems certain that a greater share falls to almost every individual than fell to the share of any corresponding class in the sixteenth century. The King keeps a more splendid court. The establishments of the nobles are more magnificent. The esquires are richer; the merchants are richer; the shopkeepers are richer. The serving man, the artisan, and the husbandman have a more copious and palatable supply of food, better clothing, and better furniture. This is no reason for tolerating abuses, or for neglecting any means of ameliorating the condition of our poorer country-men. But it is a reason against telling them, as some of our philosophers are constantly telling them, that they are the most wretched people who ever

16

existed on the face of the earth. . . .

It is not by the intermeddling of . . . the omniscient and omnipotent state, but by the prudence and energy of the people, that England has hitherto been carried forward in civilisation; and it is to the same prudence and the same energy that we now look with comfort and good hope. Our rulers will best promote the improvement of the nation by strictly confining themselves to their own legitimate duties, by leaving capital to find its most lucrative course, commodities their fair price, industry and intelligence their natural reward, idleness and folly their natural punishment, by maintaining peace, by defending property, by diminishing the price of law, and by observing strict economy in every department of state. Let the Government do this: the People will assuredly do the rest.[1]

Thus the great battle of Ruskin's life had begun long before he was of an age to bear arms in it. It was, as he saw it, a battle between beauty and ugliness, between faith and impiety, between a wisely authoritarian society and a higgledy-piggledy scramble for cash. But to most of Ruskin's contemporaries it did not appear that there was any battle, to them it seemed that Pugin and Macaulay were not truly opposed, that both had perceived some measure of truth and that in practical matters—in business or politics—Macaulay's advice was sound, while Pugin might well be consulted when it came to building a church or designing an antimacassar. Ruskin, starting from this point of view, became increasingly certain that there *was* a conflict and that it was the business of all honest men to engage in it; that you cannot

build Pugin's ideal city if your citizens abide by Macaulay's political principles, that the Gothic church in the modern industrial slum is an absurdity, that if you want good art you must have good men and if you want good men you must have a good society. The fact that his contemporaries would not, or could not, accept this doctrine exasperated him beyond endurance and his exasperation ended at last in despair and madness.

As Ruskin was later to point out, the prosperity described by Macaulay was rather less general than that writer had supposed; nevertheless it was real enough to enable John James Ruskin—the father of our subject—to rise from poverty, mend a ruined sherry business, marry, amass a great fortune, travel over the greater part of England, France, Switzerland and Italy and remove his family from Bloomsbury to a pleasant villa on Herne Hill. In this he helped to begin that steady and ever more complete urbanisation of Surrey which was to be a cause of so much distress to his only son.

For reasons which will presently become obvious I will try to deal briefly with Ruskin's youth. He was born in 1819 and he did not really grow up until he was about twenty-six. His parents were, as one may say, marsupials; they kept him safe in a pocket, safe from harm, safe from adventures or friendships or dangerous speculations. The pocket was not altogether comfortable for it had to contain, not only the infant Ruskin but the hard, heavy bulk of the family Bible. Moreover, if the child put its neck out a fraction of an inch too far it was remorselessly stuffed back again. Lady Ritchie says:

Mrs Ruskin, with all her passionate devotion to her son, seems to have had no idea of making a little

child happy. The baby's education was terribly consistent, he was steadily whipped when he was troublesome or when he tumbled downstairs.[2]

The only recorded occasion when John was allowed his own way was when, from his nurse's arms, he reached for a scalding tea urn; Mrs Ruskin grimly bade the nurse indulge the child in its whim that it might learn a first lesson in the meaning of the word "Liberty."[3]

From this Olympian severity there was no release, nor, so effectual was the compression of the boy's spirit, was there much effort to escape. He was allowed no rough and dangerous exercises, no rowdy companions. John Ruskin was educated at home and when, eventually, he left for Oxford his mother went with him and took rooms near his college.

In the carefully guarded conservatory of Herne Hill the child developed in the only directions that were permitted him. He had few toys; but he had books, first the Bible which after many readings he knew almost by heart, then Sir Walter Scott, Samuel Rogers and, more surprisingly, Byron.

That rock with waving willows on its side
That hill with beauteous forests on its top
That stream that with its rippling waves doth glide
And oh what beauties has that mountain got
The rock stands high against the sky
Those trees stand firm upon the rock
And seem as if they all did lock
Into each other; tall they stand
Towering above the whitened land.[4]

These lines were written by Ruskin before he was ten; he had already embarked upon educational

stories and, before he was sixteen, he was writing
communications to learned journals on geological and
meteorological subjects. His early diaries are full of
geology and although Mrs Ruskin, who at his birth
had devoted her son to God, dreamed of seeing her
precocious Samuel in a bishop's mitre, Ruskin himself
dreamed of becoming a great scientist.

Then, by what seems an almost incredible act of
carelessness on the part of old Mr and Mrs Ruskin, a
conservatory window was left ajar. A breath of cold
air blew in and the young plant withered. Two visits
by the daughters of M. Domecq, a partner in the sherry
business, confronted the boy with the totally un-
familiar spectacle of accomplished, personable and
prettily dressed girls. He fell violently in love. It was,
in every way, a hopeless passion and when, while he was
at Oxford, Adèle Domecq married, his health broke.
Spitting blood and writing extravagantly romantic
poetry, Ruskin was removed from Oxford and taken by
his parents first to the south of France and Italy and
then to Switzerland. In Italy he languished; but the
Alps cured him. He discovered that he wanted to live
and would live. He returned to Oxford, took his
degree and slowly recovered. It was again in the Alps,
in 1842, that he was moved by some foolish and
offensive criticisms of the painting of Turner, a
painter whom he had long admired, to attempt a reply:

> I heard falsehood taught, and was compelled to
> deny it. Nothing else was possible to me. I knew
> not how little or how much might come of the
> business, or whether I was fit for it. . . .[5]

The result was the first volume of *Modern Painters*, a
work which was, with many intervals, to engage his
energies for seventeen years.

In some ways Ruskin came very ill-equipped to the business of art criticism. The family took an intelligent interest in painting and was united in admiring Turner, but the annual visits to Italy had been made, not for pictures but for the picturesque: the Ruskins did not go in search of Raphael and Michelangelo, but rather of Childe Harold. Ruskin had, no doubt, seen a great many things in Italy but he had not studied them attentively; he was not very well read in the literature of art and although he had written some articles on architecture they had, as Dr Evans has observed, stretched his knowledge to its limits. But he had two important advantages: he had observed nature with scientific attention and he could write like an angel.

It is perhaps significant that our two greatest art critics both began as scientists; Roger Fry was a botanist, Ruskin, as we have seen, wanted to be a geologist; in both, the careful study of natural formations, a study which forces the eye to look with impartial curiosity at all that nature may show, led to the habit of clear verbal exposition and to the practice of drawing. Ruskin's early scientific articles are lucid, forceful, convincing and, like nearly everything he wrote, intensely descriptive.

The former of these rivers, when it enters the lake of Geneva, after having received the torrents descending from the mountains of the Valais, is fouled with mud, or white with the calcareous matter which it holds in solution. Having deposited this in the lake Leman (thereby gradually forming an immense delta), it issues from the lake perfectly pure, and flows through the streets of Geneva so transparent, that the bottom can be seen twenty feet below the

surface, yet so blue, that you might imagine it to be a
solution of indigo.[6]

Ruskin, at fifteen, was already laying the foundations
of that style which was to serve him so well for the
next sixty years.

The practice of drawing was of even greater impor-
tance. Ruskin's drawings just miss greatness; they are
delicate, resolute, sensitively honest, the fruit always
of careful observation. Usually precise, although at
times gracefully free, they lack only the passion of his
prose and its sensual delight in the exercise of power.
Given a subject that will stand still—and he seldom
ventures upon animated themes—he will tell you with
reverent precision exactly what it is like. But in fact
he is almost too reverent, he cannot let himself go
and one can understand why Turner only once noticed
a picture by his admirer—the *Falls of Schaffhausen*—
for not only has it something of Turner's idiosyn-
cratic manipulation of space but also an exuberant
momentum in its suggestions of wildly tumbling water
which is rare in Ruskin's paintings. For the rest
Ruskin's pictorial work excites pleasure and admira-
tion but not awe.

As a critical instrument, however, Ruskin's drawings
were of the first importance. At that date the writer
on art had no record better than the faint and flat
delineations of the engraver, he could not then work
with a library of good photographs at his elbow, he
could not compare the brushwork of a painting in
Venice with that of one in Moscow; he needed there-
fore an extremely retentive memory, abundant notes
taken on the spot and a sketchbook. But, given a
sketchbook and the ability to make good accurate
copies, he was perhaps better placed than some of his

modern successors in that he could rely, not simply upon the power of looking, but upon that more intimate sensation which arises when we have not merely gazed at, but in some measure recreated a work of art, for we know and understand a picture that we have drawn much as we know a play in which we have acted. Ruskin was still carefully transcribing details that were of interest to him long after he had begun to use photography in the study of art and architecture.

In addition to this highly trained capacity for the exact description of facts Ruskin had a rare enthusiasm for words and for all that can be embellished by poetical fancy. A child of the romantic movement, delighting in the grandeur of nature and in all the associative wealth with which nature may be adorned by the power, piety and heroism of man, accepting with enthusiasm all the ruined emblazonments of ancient chivalry, all the Gothic sublimities of medieval religion, he had nevertheless a deep and affectionate understanding for the more straitly disciplined forms of modern times—at least in literature—where he maintained a constant affection for the prose of Johnson and the poetry of Pope. Even Gibbon, whom he detested, might sometimes be invoked when he wanted to assume an air of particular dignity before embarking upon a hazardous argument:

The practice which began in the affections of a fugitive nation, was prolonged in the pride of a conquering one; and beside the memorials of departed happiness, were elevated the trophies of returning victory. The ship of war brought home more marble in triumph than the merchant vessel in speculation; and the front of St. Mark's became

rather a shrine at which to dedicate the splendour of miscellaneous spoil, than the organized expression of any fixed architectural law or religious emotion.[7]

Such measured antitheses are rare in Ruskin's prose, or rather, they are seldom so apparent. But the discipline of the eighteenth century may be divined beneath the baroque confusion that owes as much to poetry as to prose, the poetry of Scott, Byron, and Rogers, the prose of Hooker, Carlyle and, above all, the Bible.

Here then was the two-handed engine, half scientific, half-poetical, with which Ruskin came to the assistance of Turner. His method corresponds to his means. He will take some natural phenomenon, an effect of clouds or mist, cataract or declivity, and conjure it up so accurately that the reader is persuaded by sheer force of words to accept the writer's vision as his own. Then against this "objective" standard he measures the great landscape artists of the past: Claude and Salvator, Poussin, Canaletto and the Dutch, only to discover their shortcomings when compared to Turner.

The very celebrated passage on *La Riccia* may serve as an obvious example of how this is done:

There is, in the first room of the National Gallery, a landscape attributed to Gaspar Poussin, called sometimes Aricia, sometimes Le or La Riccia, according to the fancy of the catalogue printers. Whether it can be supposed to resemble the ancient Aricia, now La Riccia, close to Albano, I will not take it upon me to determine, seeing that most of the towns of these old masters are quite as like one place as another; but, at any rate, it is a town on a

hill, wooded with two-and-thirty bushes, of very uniform size, and possessing about the same number of leaves each. These bushes are all painted in with one dull opaque brown, becoming very slightly greenish towards the lights, and discover in one place a bit of rock, which of course would in nature have been cool and grey beside the lustrous hues of foliage, and which, therefore, being moreover completely in shade, is consistently and scientifically painted of a very clear, pretty, and positive brick red, the only thing like colour in the picture. The foreground is a piece of road which, in order to make allowance for its greater nearness, for its being completely in light, and, it may be presumed, for the quantity of vegetation usually present on carriage-roads, is given in a very cool green grey; and the truth of the picture is completed by a number of dots in the sky on the right, with a stalk to them, of a sober and similar brown.

Not long ago, I was slowly descending this very bit of carriage-road, the first turn after you leave Albano, not a little impeded by the worthy successors of the ancient prototypes of Veiento. It had been wild weather when I left Rome, and all across the Campagna the clouds were sweeping in sulphurous blue, with a clap of thunder or two, and breaking gleams of sun across the Claudian aqueduct lighting up the infinity of its arches like the bridge of chaos. But as I climbed the long slope of the Alban Mount, the storm swept finally to the north, and the noble outline of the domes of Albano, and graceful darkness of its ilex grove, rose against pure streaks of alternate blue and amber; the upper sky gradually flushing through the last fragments of rain-cloud in deep palpitating azure,

half aether and half dew. The noonday sun came slanting down the rocky slopes of La Riccia, and their masses of entangled and tall foliage, whose autumnal tints were mixed with the wet verdure of a thousand evergreens, were penetrated with it as with rain. I cannot call it colour, it was conflagration. Purple, and crimson, and scarlet, like the curtains of God's tabernacle, the rejoicing trees sank into the valley in showers of light, every separate leaf quivering with buoyant and burning life; each, as it turned to reflect or to transmit the sunbeam, first a torch and then an emerald. Far up into the recesses of the valley, the green vistas arched like the hollows of mighty waves of some crystalline sea, with the arbutus flowers dashed along their flanks for foam, and silver flakes of orange spray tossed into the air around them, breaking over the grey walls of rock into a thousand separate stars, fading and kindling alternately as the weak wind lifted and let them fall. Every blade of grass burned like the golden floor of heaven, opening in sudden gleams as the foliage broke and closed above it, as sheet-lightning opens in a cloud at sunset; the motionless masses of dark rock—dark though flushed with scarlet lichen, casting their quiet shadows across its restless radiance, the fountain underneath them filling its marble hollow with blue mist and fitful sound; and over all, the multitudinous bars of amber and rose, the sacred clouds that have no darkness, and only exist to illumine, were seen in fathomless intervals between the solemn and orbed repose of the stone pines, passing to lose themselves in the last, white, blinding lustre of the measureless line where the Campagna melted into the blaze of the sea.

Tell me who is likest this, Poussin or Turner?

The answer is, of course, Turner, and this for the very simple reason that Ruskin has, with his pen, painted us a Turner. Here the mechanism of Ruskin's advocacy is abundantly clear. But read on and you will come to this:

There is, on the left-hand side of Salvator's Mercury and the Woodman in our National Gallery, something without doubt intended for a rocky mountain, in the middle distance, near enough for all its fissures and crags to be distinctly visible, or, rather, for a great many awkward scratches of the brush over it to be visible, which, though not particularly representative either of one thing or another, are without doubt intended to be symbolical of rocks. Now no mountain in full light, and near enough for its details of crag to be seen, is without great variety of delicate colour. Salvator has painted it throughout without one instant of variation; but this, I suppose, is simplicity and generalization;—let it pass: but what is the colour? *Pure sky blue*, without one grain of grey or any modifying hue whatsoever; the same brush which had just given the bluest parts of the sky has been more loaded at the same part of the palette, and the whole mountain thrown in with unmitigated ultramarine. Now mountains only can become pure blue when there is so much air between us and them that they become mere flat dark shades, every detail being totally lost: they become blue when they become air, and not till then. Consequently this part of Salvator's painting, being of hills perfectly clear and near, with all their details visible is, as far as colour is concerned, broad bold falsehood, the direct assertion of direct impossibility.

27

In the whole range of Turner's works, recent or
of old date, you will not find an instance of any-
thing near enough to have details visible, painted in
sky blue. Wherever Turner gives blue, there he gives
atmosphere; it is air, not object. Blue he gives to
his sea; so does nature;—blue he gives, sapphire-
deep, to his extreme distance; so does nature;—blue
he gives to the misty shadows and hollows of his
hills; so does nature; but blue he gives *not*, where
detail, and illumined surface are visible; as he comes
into light and character, so he breaks into warmth
and varied hue: nor is there in one of his works—
and I speak of the Academy pictures especially—one
touch of cold colour which is not to be accounted
for, and proved right and full of meaning.[8]

Now this *is* convincing. We may still think that
Ruskin has been unkind to Salvator and that he has
misunderstood this picture: but this is irrelevant.
Within the terms of his argument Ruskin makes his
point: we feel that both he and Turner have looked at
mountains with more attention than did Salvator. It
is this factual certainty that gives the first volume of
Modern Painters its argumentative force, again and
again Ruskin can show that the critics of Turner
have not looked closely enough at nature, and within
its terms of reference the book stands as a reasoned
case. But as the first quotation shows, it does not
remain within those terms. Ruskin may declare that
he is going to talk only about Turner's stature as an
observer, but when he has pointed out that in every
category of nature Turner is supreme and finds
invariably that he has nothing to say of the old masters
save that "they are not here" still he must show how
much greater Turner was in the ideal and poetical

part of his work. Upon that first rock of truth to nature all others founder but Turner sails majestically on to something greater than factual truth, on into the great ocean of spiritual adventure the horizons of which are illimitable.

At this stage Ruskin can let himself go, piling up phrase on phrase, applying every device of alliterative ornament, Biblical allusion and euphonious invention, creating in fact a form of criticism which is neither descriptive nor explanatory; not so much an account as the poetical equivalent of a painting, an equivalent that bears something of the same relationship to its subject as that which an aria, fortified by every instrument in a great orchestra, may bear to its libretto

The noblest sea that Turner has ever painted, and, if so, the noblest certainly ever painted by man, is that of the *Slave Ship*, the chief Academy picture of the Exhibition of 1840. It is a sunset on the Atlantic, after prolonged storm; but the storm is partially lulled, and the torn and streaming rain-clouds are moving in scarlet lines to lose themselves in the hollow of the night. The whole surface of the sea included in the picture is divided into two ridges of enormous swell, not high, nor local, but a low broad heaving of the whole ocean, like the lifting of its bosom by deep-drawn breath after the torture of the storm. Between these two ridges the fire of the sunset falls along the trough of the sea, dyeing it with an awful but glorious light, the intense and lurid splendour which burns like gold, and bathes like blood. Along this fiery path and valley, the tossing waves by which the swell of the sea is restlessly divided, lift themselves in dark, indefinite, fantastic forms, each casting a faint and

29

ghastly shadow behind it along the illumined foam. They do not rise everywhere, but three or four together in wild groups, fitfully and furiously, as the under strength of the swell compels or permits them; leaving between them treacherous spaces of level and whirling water, now lighted with green and lamp-like fire, now flashing back the gold of the declining sun, now fearfully dyed from above with the undistinguishable images of the burning clouds, which fall upon them in flakes of crimson and scarlet, and give to the reckless waves the added motion of their own fiery flying. Purple and blue, the lurid shadows of the hollow breakers are cast upon the mist of night, which gathers cold and low, advancing like the shadow of death upon the guilty ship as it labours amidst the lightning of the sea, its thin masts written upon the sky in lines of blood, girded with condemnation in that fearful hue which signs the sky with horror, and mixes its flaming flood with the sunlight, and, cast far along the desolate heave of the sepulchral waves, incarnadines the multitudinous sea.[9]

Of what, you will have asked, was the ship guilty? Or did that adjective pass unperceived in the restless murmur of emotionally charged language? The slaver was throwing her unlucky human cargo overboard—hence the guilt, hence also the "shadow of death," the "lines of blood, girded with condemnation," the "desolate heave of the sepulchral waves," and the use of Macbeth's dreadful hyperbole.

"Still, after sixty years or so," wrote Virginia Woolf, "the style in which page after page of *Modern Painters* is written takes our breath away. We find ourselves marvelling at the words, as if all the fountains

of the English language had been set playing in the sunlight for our pleasure."[10] This is true enough and yet there were and are a great many literary critics who view Ruskin's earlier prose with misgivings. It is so overwhelmingly "literary," so bedizened with verbal finery, so patently artificial and so elaborately chased; such confections may easily induce a feeling of surfeit, a longing for something simpler and less cloying. But, if one has the stomach for it, early Ruskin is enormously enjoyable. The thing must be accepted on its own terms because, although Ruskin no doubt took pleasure in his "fitfully and furiously," his "fiery flying" and his "flaming flood" these are not mere ornaments for the sake of ornamentation. Every shred of what Ruskin himself called "verbiage" is written in earnest, every word is pondered and personal; his literary artifice is acceptable because he saw in it no more than a means to an end, he had something of the first importance to say. If one looks at some of Ruskin's contemporaries one can see at once the difference between empty verbiage and a verbiage every syllable of which is packed with serious meaning. It is this desperate sincerity which makes it possible to enjoy the sheer gusto and exuberance of Ruskin's earlier manner.

For many readers it is not Ruskin's style but Ruskin's opinions which are offensive. It must at once be admitted that there is no other great writer on art who has written so much nonsense about painting and architecture; for whereas other critics have on the whole written about work that they liked, Ruskin wrote extensively about that which he did not like. In *Modern Painters* he magnifies Turner by diminishing every other painter of landscape. Even today, it is difficult for those of us who admire

Constable to read this first volume without a mounting sense of indignation, without a suspicion that Ruskin is not only blind but wilfully dishonest. That he should accuse Constable of not being "reverent" is fair enough, that he should be said to have displayed "a morbid preference for subjects of a low order" is also fair criticism and one may accept—though with surprise—the statement that:

> I have never seen any work of his in which there were any signs of his being able to draw, and hence even the most necessary details are painted by him inefficiently.[11]

All this is pardonable but when, speaking not of beauty but of pure scientific truth, he devotes a long and exhaustive chapter to clouds and cloud formations and yet never once mentions that great master of cloud painting, Ruskin seems neither fair nor honest.

Our fury is in truth something of a tribute to Ruskin's abiding force, a force that derives from the enormous power of his criticism. For him a work of art is necessarily the result of a moral transaction and for him therefore a bad painting or, which was much the same thing, a skilful painting made upon false or vicious principles, was of necessity something odious, something to be reprehended. This moral impulse, which made him so warm and so generous an advocate, made him correspondingly severe when he sat in judgment upon an offender, and to this moral ferocity he added the scorn of one who believed that he was dealing not with disputable matters of opinion but with matters of fact. He believed that his aesthetic observations were as conclusive as those of a scientist and that, having once proved the superiority of Turner to Claude, he had made an incontrovertible

statement. This was an attitude that could more easily be adopted in the nineteenth century than in the twentieth. It was, moreover, a very natural assumption for one who made so close a connexion between morality and art and between art and science.

Speaking therefore as a moralist and man of science Ruskin tends to adopt an attitude of almost intolerable superiority; he addresses us from the pulpit, or at least from the schoolmaster's desk, and when challenged, responds with devastating acerbity.

This fierce critical manner would be hard to accept even if Ruskin were a writer of wide sympathies, but he is not; his range of affections is narrow and seemingly capricious. His tastes changed soon after the publication of the first volume of *Modern Painters* and thereafter underwent a number of variations. But from about 1845 he could endure no architecture later than that of the fifteenth century, no seventeenth-century artist save Velasquez, no Dutch or Flemish painting, no German painter save Dürer. He never looked beyond Europe, never felt the influence of China or Japan, for him French art ends with the Renaissance; he condemns the seventeenth century and disregards the eighteenth; for him nineteenth-century French painting means Edouard Frère, Rosa Bonheur and Meissonnier whom he admires, Gérôme and Gustave Doré whom he very reasonably detests. He knew nothing of Courbet or the French Impressionists.

His views are a perpetual surprise to us. We expect that a critic so deeply concerned with morality will like Rembrandt, but at an early age he learned to dismiss that "sullen and sombre" painter; or if not Rembrandt the pious Nazarenes, but he had no use for the "muddy struggles of the unhappy Germans."

33

On the other hand one would have supposed that he
would find the English portrait painters of the
eighteenth century altogether too worldly and too
frivolous, but he writes of Reynolds and of Gains-
borough with sympathetic insight; nor does one
expect him to see anything in the work of a robust
vulgarian like John Leech, of whom he speaks with
enthusiasm.[12] In the same way it is surprising that he
should have preferred Byron to Wordsworth.

I will attempt in a later chapter to account for
some of his seeming inconsistencies as an art critic; all
that need be said here is that in order to enjoy Ruskin
we must admit the necessity of following him upon a
very narrow and, at times, a rather tortuous path. He
is not one of those critics who opens a wide vista for
our admiration: but in that narrow aperture where he
can see clearly he observes with astonishing intensity
and expatiates with matchless eloquence. Moreover, it
is possible to profit by Ruskin's descriptive prose
even when we are unable to accept his judgments; the
gusto with which he condemns is enjoyable even
when he is at his most unreasonable, and, in con-
demning, he may sometimes illumine. When Ruskin,
speaking of Poussin's *Deluge* calls it "that monstrous
abortion . . . whose subject is pure, acute, mortal
fear"[13] he does not really differ from Hazlitt who
likes it, and tells us that we see:

a waste of waters, wide, interminable: the sun is
labouring, wan and weary, up the sky; the clouds,
dull and leaden, lie like a load upon the eye, and
heaven and earth seem commingling into one
confused mass.[14]

The extent to which Ruskin changed the public
estimation of Turner is doubtful; in no sense can he

be said to have "discovered" this artist: but Ruskin's own reputation was made and at the age of twenty-five he was an art critic of reputation; as such he became aware that his own art historical education was by no means complete. He began to read and to be influenced by the literature of his subject. He was, probably, particularly impressed by François Rio's *The Poetry of Christian Art.*[15]

By the fourth decade of the nineteenth century many artists and some critics were beginning to feel that the High Renaissance, which had previously been regarded as a splendid dawn of the fine arts after their long slumber through the dark ages of Gothic night, was in truth no more than a glorious sunset of art, that the painting of the late sixteenth-century, and, even more, that of the seventeenth-century Italians, was worldly and vapid, and that this was even more true of architecture, where Gothic truth perished at the hands of pagan infidelity. Ruskin could never have been untouched by these views, they were too much in the air of his century, and although it appears that he paid little attention to Pugin's exposition of them he was ready, at the age of twenty-one, to dismiss St Paul's Cathedral as "heathenish". Nevertheless, between 1841 and 1850 he made a drastic revision of his opinions. He learnt to detest Palladio whom he had once admired and in one year he completely changed his views on the Carracci.

At the time of the publication of the first volume of *Modern Painters* Ruskin was in fact a little old fashioned. During the mid eighteen-forties he was not leading, but catching up very fast with the times. He was armed with some of the latest critical weapons when, in 1845, he set off for Italy, leaving his parents

behind him, a thing he had never done before. It was
the first of many journeys, the peregrination through
Europe became an annual event for so long as he had
strength to make it. Such travelling was of course
part of the business of an art critic, particularly of
that time; what is remarkable is that these wanderings
followed such a very well-worn track. He would travel
through northern France into Switzerland and thence
to Milan, Turin, Mantua, Verona and Venice, perhaps
south to Lucca, Pisa, Florence, Assisi and Rome; as
a youth he went as far south as Paestum, which he
did not admire; that youthful excursion took him
into southern France, but he never saw Nimes, Arles,
Carcassonne or Albi. He visited Sicily once, Germany
once, Spain and the Low Countries never. It is
interesting that, in travelling, he seldom ventured
beyond the frontiers of his appreciative power. This
first solitary excursion marks an important stage in
his personal development. So far he had never been
allowed to make any decided excursion from the
parental pocket. The author of *Modern Painters* was
still treated very much as a child; it was very natural
that he should now wish to take a step which would
mark his new condition of independence, but old Mr
and Mrs Ruskin were uneasy; there had been some
minor civil commotions in Switzerland and it was
perhaps their prompting which made Turner beg his
young admirer not to venture alone. "Why will you
go to Switzerland?" he asked. "There'll be such a
fidge about you when you've gone." But Ruskin was
deaf to admonitions even from this source and at
length, with a Swiss guide and a body-servant to
protect him, he set off.

He saw and admired that which he was now
prepared to admire: Iacopo della Quercia's tomb of

Ilaria del Caretto at Lucca, the Campo Santo at Pisa, Santa Maria Novella, the Brancacci chapel and the convent of St Mark at Florence. But in Venice he made what was for him a more unexpected discovery. In the Scuola di San Rocco he came upon Tintoretto and was overwhelmed.

Tintoret, as Ruskin invariably calls him, had been noticed in the first volume of *Modern Painters* without any special enthusiasm. But now Ruskin was ready, one may almost say permitted, to give to figure painting that ardent attention which a shy adolescent will often reserve for the chaste though romantic delights of landscape. He found that which the English painter had given him in terms of mountains, oceans and tempests—a bold confusion of forms, an unrestrained glory of light and colour and everywhere that vertiginous glimpse of the heavens without which Ruskin was never really happy. But for all Tintoret's violence he was neither savage nor cold, so that Ruskin, who shrank with dismay from painful subjects, could find, even in the *Massacre of the Innocents*, a kind of warmhearted restraint that moved him profoundly.

There is a splendid inconsequence about the second volume of *Modern Painters*. It is alive with the excitement of Ruskin's new vision and his new enfranchisement: but it has very little to do with Turner. In form, he is dealing with aesthetics, a reasonable form in that his first volume dealt, nominally, with accuracy: the looseness of his theme allows him to talk about that which interested him most at the moment, which was Venetian painting. He does however attempt a definition of the beautiful, dividing that term into two categories:

First, that external quality of bodies already so often spoken of, and which whether it occur in a stone, flower, beast or in man, is absolutely identical, which, as I have already asserted, may be shown to be in some sort typical of the Divine attributes, and which therefore I shall, for distinction's sake, call Typical Beauty; and, secondarily, the appearance of felicitous fulfilment of function in living things more especially of the joyful and right exertion of perfect life in man, and this kind of beauty I shall call Vital Beauty.[16]

These categories are useful in so far as they help us to understand what Ruskin is talking about, but they hardly constitute an important contribution to the study of aesthetics. Ruskin is in fact forced to make this uneasy division because he wants to associate moral with aesthetic feelings; this is possible, at a pinch, under the heading of Vital Beauty, but when he comes to the beauty of stones and flowers he is compelled to rely on another and older theory. In fact the theorising of Volume II is tentative and inconclusive. It is not until his next volume that he really comes to grips with academic thought. Fourteen eventful years were to elapse before this third volume was published.

REFERENCES

1. Macaulay, *Essays: Southey's Colloquies*, Everyman edn. II. 220, 224.
2. Ritchie, *Records of Tennyson, Ruskin and Browning* (1896), p. 108.
3. *The Story of Arachne*, XX. 372.
4. Correspondence to his father, May 1827, XXXVI 2.
5. Preface to Vol. 5 of *Modern Painters*, VII. 10.
6. "Enquiries on the causes of the colour of the water of the Rhine," in *London Magazine*, Sep. 1834, I, 191—2.
7. *S.V.* [vol. 2.], X. 97.
8. *M.P.* [vol. 1], III, 277—81.
9. *M.P.* [vol. 1], III. 571.
10. Virginia Woolf, *The Captain's Deathbed* (1950), p. 50.
11. *M.P.* [vol. 1], III. 191.
12. *Catalogue of the Exhibition of Outlines by John Leech* (1872), XIV. 332 —4.
13. *M.P.* [vol. 2], IV. 200.
14. Hazlitt, *Complete Works* (1931), VIII. 171.
15. De la poésie Chrétienne dans son principe, dans sa matière et dans ses formes; Forme de l'Art (1836) trans. as *The Poetry of Christian Art* (1854).
16. *M.P.* [vol. 2], IV. 64.

Chapter 2

THE CRITIC AND THE THEORIST

> I hear thy name pronounced, Adèle,
> With careless lip, and heartless tone:——
> The vain magicians cannot tell
> That they have roused a master-spell,——
> A word of power, to them unknown,
> Which widely opes the crystal portal
> Of bygone moments, whence I see
> A throne where Memory sits immortal,
> And points to dreams of joy,——and thee![1]

How flat, how insipid this is when compared with the astonishing prose of *Modern Painters*. How little Ruskin means by "careless lip," or "crystal portal." How infinitely more imaginative, more rhythmic, more expressive—in a word more poetic—he is when he is not writing poetry. Ruskin himself realised this very well; he knew that he had found the form proper to his peculiar genius in *Modern Painters* and, much to his father's grief, he wrote no more verse after 1845.

It was under the influence of Adèle Domecq that he wrote his most successful poetry. Another girl, his cousin Euphemia Gray, inspired his best attempt at fiction—a form for which he also knew that he had little talent. *The King of the Golden River* was written when she was thirteen and he twenty-two. It is an overwhelmingly moral fairy tale but one which, I have found, can still be read with enjoyment by a child of six. Seven years later, when Effie had become a remarkably beautiful woman and John a highly successful young author, they were married.

Ruskin's marriage is a theme to which biographers advert with regret and to which they usually devote many pages. At this point I will say only that the marriage was never consummated. For six years Mr and Mrs Ruskin enacted an increasingly sad travesty of married life. It was brought to an end when in the autumn of 1854 the young, handsome, enormously gifted Millais stayed with the Ruskins for a few weeks in the Highlands. Then the situation suddenly reached breaking-point. Millais fell in love with Mrs Ruskin, led her to look desperately for some means of escape from her phantom marriage, to find it in a suit for nullity and, after a resounding scandal, to become Mrs Millais.

During these years of courtship and estrangement Ruskin was led astray from *Modern Painters* and returned to his first critical theme, the study of architecture. Kenneth Clark suggests that Ruskin was drawn to this study by a growing awareness of his power as an architectural draughtsman, a power which enabled him to produce "some of the most beautiful architectural drawings ever executed." It is a convincing explanation, but to this I may perhaps add the suggestion that, at heart, Ruskin was always inclined to alternate between art criticism and social theory. The history of architecture enabled him to discuss, much more appropriately than was possible in the study of landscape, the religious questions that were already troubling him and the social problems of which he was now dimly aware. This alternation was to become a typical feature of his later activities. At all events and for whatever reason, *Modern Painters* was temporarily abandoned in 1847. In 1849 Ruskin published *The Seven Lamps of Architecture*, a kind of introductory volume to

The Stones of Venice, which appeared in three volumes and engaged the author's attention until 1852.

The Seven Lamps of Architecture is the tidiest of Ruskin's books (and that which he himself liked least). Architecture, he says, should be an offering to God (the Lamp of Sacrifice); it should embody honest workmanship and should itself be honest in the sense that the quality of materials should be respected—stucco should not imitate marble, cement should not pretend to be stone (the Lamp of Truth). A building should be well sited and should be conceived above all as a shape, using sunlight for the definition of its masses (the Lamp of Power); it should be adorned, not with conventional forms, but with patterns derived from nature (the Lamp of Beauty). Ornament and work of every kind should not seek dead, mechancal uniformity but should bear the character of the human hand (the Lamp of Life). Architecture should respect not only the purely formal but also the associative, historical, or sentimental character of its situation (the Lamp of Memory). Finally it should be relevant to its social context, it should in some sort be the embodiment of the polity, life, history, and religious faith of nations (the Lamp of Obedience). It will be seen, even without quoting Ruskin's many remarks concerning the Gothic style, whither these arguments were tending. The architecture of the Middle Ages could stand scrutiny in the light of any one of these principles, but Palladian architecture was worldly, artificial, geometrical and, in that it was pagan, alien; it might be lit only by the Lamp of Power or the Lamp of Memory. It is, as Ruskin put it: "utterly devoid of all life, virtue, honourableness, or power of doing good. It is base, unnatural, unfruitful, unenjoyable and impious."[2]

Ruskin was not the first to hold such views and here, certainly, he cannot be accounted an innovator. His advocacy of Gothic summarises and formulates the opinions of his time, the opinions, that is to say, of a generation which no longer regarded pinnacles and pointed arches as mere properties which might produce an effect of archaic sublimity and romantic grandeur, but rather as a style based upon sound principles of structure, expressive of the highest religious earnestness and a state of social coherence and strict piety entirely opposed to the frivolous infidelity of the past three hundred years, the architecture of Christian fellowship as opposed to that of monarchs and magnates. It was thus that Pugin and his friends saw the matter and Ruskin adds very little to their arguments.

The affinity between the Gothic engineer in stone and the modern engineer in iron could not be ignored and there were times when Ruskin was amazingly clairvoyant on this subject:

> Abstractedly there appears no reason why iron should not be used as well as wood; and the time is probably near when a new system of architectural laws will be developed, adapted entirely to metallic construction. . . .[3]

But Ruskin shrank from the implications of such a doctrine; he hastened to exclude iron on historical and also on theological grounds.

The great obstacle that made it impossible for the majority of Englishmen to accept the doctrines of Pugin was sectarian. Pugin was a Roman Catholic convert, with all the aggressive enthusiasm of a convert; many other enthusiasts for Gothic architecture were also tainted, or supposed to be tainted, with

"Romanism." Ruskin who was at this time staunchly Protestant, gave comfort and reassurance to those who wanted to admire pointed arches but were frightened of discovering in them an engine of Popery. In *The Seven Lamps of Architecture* Ruskin set their minds at rest:

> The treatment of the Papists' temple is eminently exhibitory; it is surface work throughout; and the danger and evil of their church decoration altogether, lie, not in its reality—not in the true wealth and art of which the lower people are never cognizant—but in its tinsel and glitter, in the gildings of the shrine and painting of the image, in embroidery of dingy robes and crowding of imitated gems; all this being frequently thrust forward to the concealment of what is really good or great in their buildings. Of an offering of gratitude which is neither to be exhibited nor rewarded, which is neither to win praise nor purchase salvation, the Romanist (as such) has no conception.[4]

This must have made comfortable reading for the Low Church enthusiast. Ruskin deleted it from later editions, adding a footnote:

> Thirteen lines of vulgar attack on Roman-Catholicism are here—with much gain to the chapter's grace, and purification of its truth—omitted. (1880)[5]

Nevertheless, I do not think that Ruskin was simply indulging in religious spleen. It was perfectly consistent to feel a whole-hearted admiration for medieval Christian art and at the same time to be appalled and repelled by the trimmings of Christian worship as they existed in the Italy of 1840 or,

indeed, as they still exist today. The cheap sentimentalities of the modern image-maker, the paper flowers, rococo decorations and enthusiastic vulgarity of southern *bondieuserie* must have seemed very strange and shocking to an aesthetic and devout Anglo-Saxon, nor had Ruskin—in his youth at all events—the strength of sympathy that could enable him to understand the cheerful, superstitious hedonism of the Italians. He loved Venice, but he did not love the Venetians.

The Stones of Venice follows naturally from *The Seven Lamps of Architecture*; in the first book he considers the principles, in the second the practice of architecture. He himself summarises the argument in the following way:

> Christianity gave birth to a new architecture, not only immeasurably superior to all that had preceded it, but demonstrably the best architecture that *can* exist . . . In the course of the fifteenth century . . . the Christianity of Europe was undermined; and a Pagan architecture was introduced . . . We must give up this style totally, despise it and forget it, and build henceforward only in that perfect and Christian style hitherto called Gothic, which is everlastingly the best.[6]

The book is admirable for its argumentative skill and for its descriptive passages. Ruskin evokes Venice with its splendours and graces, its noise, narrowness and confusion; he analyses the structure of its buildings, and more particularly St Mark's, with the perceptive exactitude that he brought in *Modern Painters* to the examination of mists and mountains. In attempting to prove that Gothic is indeed the best architecture that *can* exist (he even proves that it is

the most economical) he is at his most persuasive. The reader is to take nothing on trust, he is to be free to agree or disagree with the author; he is then led step by step to discover just what Ruskin wants him to discover; as advocacy it is far more impressive than the first volume of *Modern Painters*.

But in *The Stones of Venice* Ruskin is not simply concerned with architecture. He announces his intention in his opening lines:

> Since first the dominion of men was asserted over the ocean, three thrones, of mark beyond all others, have been set upon its sands: the thrones of Tyre, Venice and England. Of the First of these great powers only the memory remains; of the Second, the ruin; the Third, which inherits their greatness, if it forget their example, may be led through prouder eminence to less pitied destruction.[7]

It is, surely, a splendid opening, and has a Turnerian quality reminiscent of *Ulysses deriding Polyphemus* or *The "Fighting Téméraire" tugged to her last berth*. But whatever art Ruskin might bring to the enunciation of truth it was the truth itself that concerned him; Venice fell, England may do likewise. Why then did she fall?

To Ruskin it seems that the rise of the Republic and its apogee, which he places between 1360 and 1423, are something inseparable from the development of Venetian Gothic.

> Architecture can only be built by a thoughtful Nation, and a Pure Nation, living up to its conscience,—who have a Common Pride, and a Common Wealth.[8]

Ruskin wrote this many years later, but it embodies

the central argument of *The Stones of Venice*. He sees a crisis in Venetian history, an encounter with fortune that was met and shirked in 1423 when the destruction of the old Ducal Palace was decided. The following year, on 27 March, the first hammer was lifted up against the old palace of Ziani:

> That hammer stroke was the first act of the period properly called the "Renaissance". It was the knell of the architecture of Venice,—and of Venice herself.[9]

Thereafter, faith, morals, art and empire, all decline.

As an historical analysis this is quite untenable; the material factors affecting Venice, the diversion of trade routes, the growth of her rivals, are disregarded. Even within the terms of his own aesthetic preferences Ruskin is hardly consistent, or can remain consistent only by making a division between painting and architecture which in another context he would never have accepted. The great flowering of Venetian painting begins just when Ruskin would have us believe that Venice herself began to decline.

Ruskin failed, where many of us have failed, in attempting to find a clear correspondence between that which we admire in art and that which we approve in social arrangements; it is an impossible task for we must either admire too little or approve too much. Nevertheless he had perceived an important truth, the truth that is illumined by the "Lamp of Obedience."

The Stones of Venice, despite much professional opposition, soon became Ruskin's most influential work. British architects set themselves with deadly enthusiasm, great skill and increasing archaeological knowledge to recreate Venetian Gothic. Cusped

arches, foliated capitals, floral carving and polychrome effects of stone, marble, brick or encaustic were employed to enliven police stations, town halls, board schools, public lavatories, gin palaces and emporia. Ruskin himself was horrified by the effect of his own words, all the more so as the tide of Venetian Gothic swept up to his house on Denmark Hill:

> . . .I have had indirect influence on nearly every cheap villa-builder between this and Bromley; and there is scarcely a public-house near the Crystal Palace but sells its gin and bitters under pseudo-Venetian capitals copied from the Church of the Madonna of Health or of Miracles. And one of my principal notions for leaving my present house is that it is surrounded everywhere by the accursed Frankenstein monsters of, *in*directly, my own making.[10]

Today Victorian Gothic has its admirers and it may be that the public houses of South London have their champions. But I think that it would be agreed whether one likes them or not that such monuments of nineteenth-century culture are completely unlike their prototypes. As imitations, at all events, they fail and the very idea of imitating a fourteenth-century model in the middle of the nineteenth century, or, for that matter, of building georgian palaces in our own time, is about as sensible as it would be to curl the bristles of a pig in the hope of turning it into a sheep. Victorian England could not produce medieval Venetian architecture for the simple reason that it was not medieval Venice. If you wanted a different kind of art you would have to begin by producing a different kind of society. Ruskin was perfectly right in seeing this connexion and now,

in the eighteen-fifties, he was beginning to see also that the essential problem was not artistic but social.

When Ruskin was finishing his *Seven Lamps of Architecture* and embarking upon the first volume of *The Stones of Venice*, he turned his attention to contemporary art. He emerged suddenly and dramatically as the champion of the Pre-Raphaelite Brotherhood.

Here again he was not a pioneer and it is certainly quite untrue to say, as has been said, that he led the movement. Of the actual leaders Holman Hunt and the sculptor Woolner were deeply impressed by *Modern Painters*, but Millais and Rossetti never entirely accepted Ruskin's opinions. The doctrines of the Brotherhood were never clearly formulated nor is it certain how much of Ruskin's teachings were known at the time of its formation, even to Holman Hunt.

The bretheren were commonly accused of archaism, but it is probable that it was their realism which most shocked the public. The so called *Carpenter's Shop* of Millais was offensive to the critics and the world at large in that it showed the Holy Family not as that splendid and dignified assembly which Raphael might have imagined, but as a collection of very ordinary and rather ugly artisans. It was William Dyce who induced Ruskin to look seriously at *The Carpenter's Shop* and, in the following year, Coventry Patmore persuaded him to look at *Mariana* by the same artist. Then, in two long, judicious and careful letters to *The Times* Ruskin demolished the enemies of the Brotherhood as he had demolished the enemies of Turner:

These pre-Raphaelites (I cannot compliment them on common sense in choice of a *nom de guerre*)

do *not* desire nor pretend in any way to imitate antique painting as such. They know very little of ancient paintings who suppose the works of these young artists to resemble them. . . . They intend to return to early days in this one point only,—that, as far as in them lies, they will draw either what they see, or what they suppose might have been the actual facts of the scene they desire to represent, irrespective of any conventional rules of picture-making; and they have chosen their unfortunate though not inaccurate name because all artists did this before Raphael's time, and after Raphael's time did *not* this, but sought to paint fair pictures, rather than represent stern facts; of which the consequence has been that, from Raphael's time to this day, historical art has been in acknowledged decadence.

Now, Sir, presupposing that the intention of these men was to return to archaic *art* instead of to archaic *honesty*, your critic borrows Fuseli's expression respecting ancient draperies "snapped instead of folded", and asserts that in these pictures there is a "*servile* imitation of *false* perspective." To which I have just this to answer:—

That there is not one single error of perspective in four out of the five pictures in question; and that in Millais' *Mariana* there is but one—that the top of the green curtain in the distant window has too low a vanishing-point; and that I will undertake, if need be, to point out and prove a dozen worse errors in perspective in any twelve pictures, containing architecture, taken at random from among the works of the popular painters of the day.

In both letters he found fault with the young men,

but such fault finding only served to reinforce his praise and at the end he expresses the hope that they may:

...as they gain experience, lay in our England the foundations of a school of art nobler than the world has seen for three hundred years.[11]

For a time Ruskin had the exhilarating experience of being the spokesman of a young and growing movement, a movement which, with his aid, seemed to be carrying all before it. In 1856 he signalled the victory:

the battle is completely and confessedly won . . . animosity has changed into emulation, astonishment into sympathy . . . a true and consistent school of art is at last established in the Royal Academy of England.[12]

This prosperous conflict brought him into close and friendly contact with the young painters, he bought their pictures and made others do likewise.

Ruskin's three principal friends among the Pre-Raphaelites were Millais, Rossetti and Burne Jones. As we have seen, the friendship with Millais ended in disaster. With Rossetti and Burne-Jones there were difficulties of another sort. Ruskin was kind to them and to their wives, he helped them financially, he scolded them gently when they were imprudent: but he claimed, naturally enough, the right to criticise their work, and this they found hard to bear.

Rossetti, certainly, was unwilling to receive Ruskin's lectures on art. Ruskin, he felt, might give him good publicity but that did not mean

that he really knew what he was talking about:

as he is only half informed about Art anything he says in favour of one's work is of course sure to prove invaluable in a professional way, and I only hope, for the sake of my rubbish, that he may have the honesty to say publicly in his new book what he has said privately, but I doubt this. Oh! Woolner, if only one could find the "supreme" Carlylian Ignoramus, him who knows positively the least about Art of any living creature—and get *him* to write a pamphlet about one—what a fortune one might make.[13]

Whether Rossetti in his disrespectful way privately considered Ruskin to be the "supreme Carlylian Ignoramus" I do not know, but certainly Ruskin did a great deal to make his protégé's fortune and Rossetti, while cheerfully pocketing the proceeds, was certainly not going to repay his patron with any kind of deference. Ruskin was too kind, Rossetti was too realistic for either side to make a complete break, but the friendship slowly died.

Burne-Jones, a younger and humbler man, accepted Ruskin's benevolence and his advice for a longer period, but he too ended by drifting away from this too cultivated Mæcenas and, as we shall see, quarrelled with Ruskin on a point of principle.

Ruskin's alliance with the Pre-Raphaelites identified him in the public mind with the most extreme doctrines of realism. A parody of the Pre-Raphaelite style, painted by Florence Claxton the illustrator, shows Ruskin, a frock-coated Paris, awarding the apple of discord to a hideous sinewy hag while her competitors, a pretty girl in a crinoline and the Madonna of Raphael's *Sposalizio*, stand rejected.[14] It

was thus, as the foe of the Ideal, that Ruskin appeared to many of his contemporaries. A celebrated passage in the first volume of *Modern Painters* had done much to reinforce this belief:

> go to Nature in all singleness of heart, and walk with her laboriously and trustingly, having no other thoughts but how best to penetrate her meaning, and remember her instruction; rejecting nothing, selecting nothing and scorning nothing; believing all things to be right and good and rejoicing always in the truth.[15]

And yet Ruskin never came near to such complete naturalism as this. The passage is usually quoted out of a context which makes it clear that these words are addressed to students. Sir Joshua Reynolds, whom no one will accuse of naturalism, gives much the same advice to the young.

At this point I want to try to define Ruskin's position in relation to academic theory, that is to say the position that he had reached by 1860 when he at last brought *Modern Painters* to an end. This is likely to make dreary reading to those who are not interested in the history of ideas about art: they may therefore be well advised to proceed at once to Chapter III.

Academic theory revolves around the relationship between the artist and nature and it commonly ends in obscurity because we cannot tell what the theorist has in mind when he uses the word "nature." As Roger Fry has pointed out, it is this that makes Reynolds' "Third Discourse" so perplexing. With Ruskin also the use of the word may lead to confusion. For us, "nature" is the world outside the canvas—the world of natural appearances. That certainly is not Ruskin's meaning. For him the Rhine

is "nature" but an iron bridge spanning that river is not. A modern iron bridge is something that has no place in a work of art; this, however, does not mean that the artist is to confine himself to the depiction of God's handiwork—Ruskin was, after all, an architectural draughtsman—but it does mean that "nature" in the Ruskinian sense has a particular value and that the works of man are to be treated with reserve. This is a point in which he can find fault even with Turner:

Margate is simply a mass of modern parades and streets, with a little bit of chalk cliff, an orderly pier, and some bathing-machines. Turner never conceives it as anything else; and yet for the sake of this simple vision, again and again he quits all higher thoughts. The beautiful bays of Northern Devon and Cornwall he never painted but once, and that very imperfectly. The finest subjects of the Southern Coast series—the Minehead, Clovelly, Ilfracombe, Watchet, East and West Looe, Tintagel, Boscastle—he never touched again; but he repeated Ramsgate, Deal, Dover and Margate, I know not how often. . . .

It is certainly provoking to find the great painter, who often only deigns to bestow on some Rhenish fortress or French city, crested with Gothic towers, a few misty and indistinguishable touches of his brush, setting himself to indicate, with unerring toil, every separate square window in the parades, hotels and circulating libraries of an English bathing-place.[16]

We have travelled so far from the assumptions of Romantic art that it is not easy for us today to sympathise with Ruskin's distress and perhaps it is the very quality of prosaic life contrasted with the

romantic grandeur of the sea, no less than the play of rigid urban quadrilateral shapes against the convulsive agitation of the waves that for us gives this particular picture its value.

In Ruskin's view—and in that of most of his contemporaries—the painter was very much at the mercy of his subject. He regretted that no one in Turner's youth had had "sense or feeling enough to say to him 'paint me the Rhone as you have painted the Thames'." It is not a ridiculous attitude; the heroic subject *can* draw forth heroic art: but it was an attitude which, when carried as far as Ruskin carried it, closed certain doors which a critic of wider sympathies would have left open. Rembrandt's flayed ox, Bruegel's clowns, Chardin's domesticities could not receive their due under regulations such as these.

In that he believed in a hierarchy of pictorial themes Ruskin was close to the academic theorists, although his hierarchy was not their hierarchy. He was also at one with the academicians in that he had doubts about Nature herself. Poussin and Claude are blamed for imitating the tufa and travertine of the lower Apennines—"the ugliest as well as the least characteristic rocks of nature."[17] This was written in Ruskin's youth, but in old age he was ready to go much further:

when we come to the colours of flowers and animals, some of these are entirely pure and heavenly; the dove can contend with the opal, the rose with the clouds, and the gentian with the sky; but many animals and flowers are stained with vulgar, vicious and discordant colours. But all those intended for the service and companionship of man are typically fair in colour. . . .[18]

55

Again Ruskin agrees with the academicians, and with almost everyone who has considered pictorial art seriously, when he says that imitation for its own sake is a poor form of art, "great painting never deceives" and "a photograph is no more true than an echo."

But he begins to differ from the followers of Reynolds when they recommend that form should be generalised. Generalisation seemed to Ruskin a mere excuse for slovenliness. Detail was to be sought, detail reconciled with breadth.

It is not, therefore, detail sought for its own sake, not the calculable bricks of the Dutch house-painters, nor the numbered hairs and mapped wrinkles of Denner, which constitute great art, they are the lowest and most contemptible art; but it is detail referred to a great end, sought for the sake of the inestimable beauty which exists in the slightest of God's works, and treated in a manly, broad and impressive manner. . . .

I cannot give a better instance than the painting in of the flowers in Titian's picture. . .every stamen of the rose is given, because this was necessary to mark the flower, and while the curves and large characters of the leaves are rendered with exquisite fidelity, there is no vestige of particular texture, of moss, bloom, moisture, or any other accident, no dewdrops, nor flies, nor trickeries of any kind . . . the master does not aim at the particular colour of individual blossoms; he seizes the type of all, and gives it with the utmost purity and simplicity of which colour is capable.[19]

Thus at the time when he wrote the first volume of

Modern Painters, Ruskin held that the painter should give us the essence rather than the peculiarities of nature, and by nature he meant that which was seemly and beautiful in the world of natural appearances. But there were forces that were moving him to a more radical position, his dislike of the High Renaissance, his detestation of those artists who can most truly be called academic, his distrust of the nude and the antique.

In the second volume of *Modern Painters* Ruskin makes a more determined attack upon Reynolds. He was not quite whole-hearted in this, for he admired Reynolds, both as a man and as an artist, and although it is not hard to separate Reynolds from his theories Ruskin was not always ready to make such a distinction.

Now Reynolds' theory, which derives from Alberti and the academicians of the seventeenth century, may be briefly summarised thus: ugliness results from abnormality, it is a deformation of nature. The fact that we are repelled by deformity implies that we admire some opposite quality, some state of unblemished regularity which Reynolds calls the "middle form." Earlier theorists had stated this theory in theological terms. Man would be perfectly beautiful if he were cast in the shape which God intended him to assume; but, owing to the corruption of all material bodies, man can ever quite attain this perfection. It is the business of the artist to divine the intentions of the Master of all things and to represent them, not as they are, but as they ought to be. Reynolds, a child of the Enlightenment, omits this theological argument and ascribes our pleasure in normality to nothing more extraordinary than the effect of custom. If our ideal of beauty were that of the Hottentot or

the Chinese then that which we think beautiful would become ugly. This was a view which Ruskin found insupportable and in addition to attacking the main doctrine of "middle form" he attacked this relativist conception of it:

the world has never succeeded, nor ever will, in making itself delight in black clouds more than in blue sky, or love the dark earth better than the rose that grows from it. Happily for mankind, beauty and ugliness are as positive in their nature as physical pain and pleasure, as light and darkness, or as life and death; and though they may be denied or misunderstood in many fantastic ways, the most subtle reasoner will at last find that colour and sweetness are still attractive to him, and that no logic will enable him to think the rainbow sombre, or the violet scentless.[20]

It is strange that Ruskin, who spent so much of his life in trying to change men's conceptions of beauty, should have thought it so easy to perceive rightly. In the matter of the "middle form" itself he is more subtle. Human beauty, he suggests, is determined by the moral state of each individual, but it is not the ideality of man, the main stock-in-trade of the academic theorist, that he takes as his example, but what he calls "Ideal form in vegetables."

That which we have to determine is, whether ideality be predicable of fine oaks only, or whether but poor and mean oaks also may be considered as ideal, that is, coming up to the conditions of oak, and the general notion of oak.

Now the finest imaginable oak is that which grows in a park where it is carefully tended, where parasites

are removed and it has no competitors, where it is in fact an abnormal tree under abnormal conditions. As for the other oaks, the oaks in forests or hedgerows, these have all been in one way or another stunted or malformed by the particular circumstances of their situation so that in fact none can be held typical.

So then there is in trees no perfect form which can be fixed upon or reasoned out as ideal; but that is always an ideal oak which, however poverty-stricken or hunger-pinched or tempest-tortured, is yet seen to have done, under its appointed circumstances, all that could be expected of oak.[21]

Undoubtedly Ruskin makes Reynolds look very silly, but is he himself in much better case? The middle form vanishes, but so, it would seem, does the ideal; for are we seriously to suppose that an oak has some kind of ideality when it is doing its duty in that state of life to which it has pleased God to call it? Even if we allow the existence of a state of moral effort in the vegetable kingdom are we to imagine that there are lazy or procrastinating oaks? Does it not rather appear that all oaks are perpetually struggling to live, all equally praiseworthy, all therefore equally ideal so that, in fact, the term ends by becoming meaningless?

In the third volume of *Modern Painters* Ruskin attacks Reynolds' conception of the Grand Style and here, I think, he may have been directly influenced by the Pre-Raphaelites. Again he has no difficulty in demolishing the arguments of the Discourses:

All [Reynolds'] successive assertions are utterly false and untenable, while the plain truth, a truth lying at the very door, has all the while escaped

him ... namely that the difference between great and mean art lies, not in definable methods of handling, or styles of representation, or choices of subjects, but wholly in the nobleness of the end to which the effort of the painter is addressed...

And it does not matter whether he seeks for his subjects among peasants or nobles, among the heroic or the simple, in courts or in fields, so long only that he beholds all things with a thirst for beauty, and a hatred of meanness and vice.[22]

It is not easy for us to accept Ruskin's moral terminology. But this is an important truth and one which justifies us in seeing in Ruskin the grand executioner of academic theory. It was a point worth making that the difference between great and mean art is certainly to be found nowhere but in the sentiment of the artist. It is not a matter of canonical rules or approved manner, but of a species of innocence or integrity which is indeed moral.

Where we must differ from Ruskin is in his belief that the moral stature of the artist must be of so clearly recognisable a kind that we may comprehend his thirst for beauty wherever it may lead him and agree with him as to what constitutes virtue and what vice; but this was a matter on which Ruskin himself was to have second thoughts.

In this discussion of Ruskin's contribution to academic thought I have borrowed from the third volume of *Modern Painters*. I shall quote passages from later volumes in my next chapter. Their character makes such treatment appropriate. It is in fact much harder to indicate their tenor.

The third volume was published in 1856; the fourth and fifth volumes despite many interruptions

were completed by 1860. Ruskin addressed himself to the business without enthusiasm; he was always more ready to start a book than to finish one, he was continually finding new things to be done and in the end it was only his father's persuasion that brought him to the task.

The books themselves show signs of this faltering purpose. They lack the indignant urge that inspired Volume I or the new-found enthusiasm which informs Volume II. Morris was not far wrong when he described Volume V as being "mostly gammon." And yet there are some fine and some very important passages that should be noted: the definition of the pathetic fallacy in Volume III, that which consists in attributing to nature the emotions of the spectator—a fallacy from which Ruskin himself derives some of his most poetical effects; the very convincing essay on light in Volume IV where there is also the extraordinarily influential discussion of "curves of beauty"—those curves which are capable of indefinite extension —curves which were to reappear in the Art Nouveau of the late nineteenth century; Ruskin's first essay in comparative mythology; hazardous but very readable speculations upon the symbolism of Greek legends; a wonderfully convincing analysis of the grotesque; some very sound criticism of Sir Walter Scott's novels.

But when all is said and done, these three volumes lack structure and purpose. They make good material for anthologies but they are not coherent books. Ruskin's whole conception of art lends itself to an untidy treatment. If he had been able to confine himself to landscape painting, or, better still, the work of Turner, he might have made a more or less systematic treatise. But in fact he could be content with nothing less than an essay upon painting as a

whole, upon nature as a whole and upon the whole
work and life of man in this universe. In fine, the
task that he set himself was impossible and he was
bound to fail. But in the entire history of literature it
would be hard to think of a more glorious failure
than this.

REFERENCES

1. "Evening in Company—
May 18," II. 461.
2. *S.V.* [vol. 3], XI. 227.
3. *S.L.A.*, VIII. 66.
4. *S.L.A.*, VIII. 41. note 3.
5. *Ibid.*
6. *S.V.* [vol. 3 explanatory
note], XI. 356.
7. *S.V.* [vol. 1.], IX. 17.
8. "The Flamboyant Archi-
tecture of the Valley of
the Somme," (a lecture
at the Royal Institution,
29 Jan. 1869), XIX, 263
9. *S.V.* [vol 1], X. 352.
10. Letter to the *Pall Mall
Gazette*, 16 Mar. 1872.
S.V. [vol. 2], Appen-
dix 13. X. 459.
11. Letters to *The Times*, 13
May and 16 May 1851,
XII. 321—7.

12. *Academy Notes* 1856,
XIV. 47.
13. Amy Woolner, *Thomas
Woolner, his life in
Letters* (1917), p. 52.
14. See William E. Fredeman
in *The Burlington Maga-
zine*, CII, No. 693, Dec.
1960.
15. *M.P.* [vol. 1], III. 624.
16. *The Harbours of Eng-
land*, XIII. 60—2.
17. *M.P.* [vol. 1] III. 473.
18. *Laws of Fesole*, XV. 418.
19. *M.P.* [vol. 1], III. 32—3.
20. *M.P.* [vol. 3], V. 45.
21. *M.P.* [vol. 2], IV. 169,
170.
22. *M.P.* [vol. 3], V. 42.

Chapter 3

THE CLIMACTERIC

In 1860 Ruskin shocked his public by writing a treatise on political economy. It appeared in the *Cornhill Magazine* and was later published under the title *Unto this Last*. Political economists had proved, or were thought to have proved, that man was a "covetous machine" which would respond, automatically, to the state of a market and, so long as it was left free to do so, would, by the operation of the law of supply and demand, achieve its own prosperity. Some hardships might occur in this process but any interference with the operation of economic laws would only bring disaster on those whom it was designed to help; salvation lay always in the operation of enlightened self-interest.

Ruskin's articles were devoted to the proposition that this theory is complete nonsense, that the miseries inflicted by modern capitalism were neither inevitable nor in any way useful; that the economic theory of Ricardo and Mill was a cloak for inefficiency, stupidity, inhumanity and greed. I cannot rehearse his arguments nor would I, for *laissez-faire* has few votaries today, but there is one aspect of Ruskin's political thinking which is typical both in its romantic origin and in its realistic clarity. Ruskin asks why it is that what he calls "social affection" has been disregarded by the political economists.

It is easy to imagine an enthusiastic affection existing among soldiers for the colonel. Not so easy to imagine an enthusiastic affection among

cotton-spinners for the proprietor of the mill.[1]

Indeed it is not; nor can one overestimate the importance of Ruskin's observation. He was later to declare:

You have founded an entire Science of Political Economy, on what you have stated to be the constant instinct of man—the desire to defraud his neighbour.[2]

Ruskin was right in denouncing such a system as nonsense but might it not have been better if he had been wrong; It was not enlightened self-interest but "social affection" that made it possible for the rulers of Europe to lead their peoples into wars of unexampled horror and tyrannies of unspeakable beastliness. Ruskin has been proved dreadfully right.

Readers of the *Cornhill*, however, could not be expected to see matters in this light. To them it appeared, quite simply and quite rightly, that Ruskin was accusing them of fraud and theft. The *Saturday Review*, the voice of cultured and educated England in the mid-nineteenth century, undoubtedly voiced the opinion of its readers when it declared that Ruskin was "weeping and bawling," throwing out "constant eruptions of windy hysterics" and writing "in a scream on serious subjects which should be handled in the grave and quiet tone which educated men and women ought to employ."

To English feelings, the most revolting part of Mr Ruskin's performance is his gross calumny on the nation to which he belongs. Ours is not a country to cry about. Philanthropic gentlemen are infinitely too ready with their pity. It is simply false and absurd to assert that a man who is industrious

64

and sober—and how the rich prevent the poor from being either utterly passes our understanding—cannot, as a rule, get a living here.[3]

The outcry was so violent that Thackeray, who was then editor of the *Cornhill*, had, most uncomfortably and apologetically, to cancel the fourth instalment.

Ruskin had a literary style that could delight, but it could also hurt. He was now anxious that it should hurt. Listen to him then talking to the manufacturers of Bradford in one of the many lectures that he delivered at this period, and remember, incidentally, that his audience had come expecting a nice chat about architecture:

Your ideal of human life then is, I think, that it should be passed in a pleasant undulating world, with iron and coal everywhere underneath it. On each pleasant bank of this world is to be a beautiful mansion, with two wings; and stables, and coach houses; a moderately-sized park; a large garden and hot-houses; and pleasant carriage drives through the shrubberies. In this mansion are to live the favoured votaries of the Goddess [of "getting-on"] ; the English gentleman, with his gracious wife, and his beautiful family; he always able to have the boudoir and the jewels for the wife, and the beautiful ball dresses for the daughters, and hunters for the sons, and a shooting in the Highlands for himself. At the bottom of the bank, is to be the mill; not less than a quarter of a mile long, with one steam engine at each end, and two in the middle, and a chimney three hundred feet high. In this mill are to be in constant employment from eight hundred to a thousand workers, who never drink, never strike, always go to church on Sunday, and

always express themselves in respectful language.

Is not that, broadly, and in the main features, the kind of thing you propose to yourselves? It is very pretty indeed, seen from above; not at all so pretty, seen from below.[4]

Here Ruskin employs a weapon of some delicacy, but he is perfectly ready to use a bludgeon. In *Sesame and Lilies* he prints—in red ink—the account of an inquest on a cobbler in Spitalfields. The deceased "Died from exhaustion from want of food and the common necessaries of life; also through want of medical aid"; the details are ghastly enough. Then as a footnote he adds a paragraph from the *Morning Post* describing the foods, the wines, the company—"some English peers and members of Parliament were present and appeared to enjoy the animated and dazzlingly improper scene"—at the house of a Parisian whore.

This sort of thing got Ruskin into a great deal of trouble, his father was distressed, his friends were puzzled, his public was angry. It was all very well for him to write about art, and at a pinch to throw in a few sermons, after all books on art need not be taken very seriously: but this was the kind of thing which, if it got into the wrong hands, might do no end of mischief; and at any rate what business had an art critic with political economy?

The answers to this question are a matter of direct interest to Ruskin's biographer. In the first place it has to be remembered that Ruskin was in a terribly simple and direct way religious; he was astonished by the ability of his countrymen to deny on weekdays that which they preached on Sundays.

The Greeks in their decline jested at their religion ... the French ... tore down their altars

and brake their carven images. The question about God with both these nations was still, even in their decline, fairly put though falsely answered: "Either there is or there is not a Supreme Ruler; we consider of it, declare there is not, and proceed accordingly." But the English have put the matter in an entirely new light: "There *is* a Supreme Ruler, no question of it, only He cannot rule. His orders won't work. He will be quite satisfied with euphonious and respectful repetition of them. Execution would be too dangerous under existing circumstances, which he certainly never contemplated."[5]

He knew very well that he was an exceedingly fortunate man, that he had lived at ease and that, even on his father's allowance, there were few luxuries that he could not purchase. Already at the age of nineteen he was wondering on what principle he was allowed such pleasures and on what principle they were denied to others. To these natural feelings of guilt and compassion he added a certain disrespect for the standards and beliefs of his own class and a corresponding veneration for the paternal and socially responsible rule of aristocracy. His Venetian studies had convinced him that art was a symptom of social health and turning from Venice to the great squalid, poverty-racked chaos of London he wondered amidst the gasometers of the Brentford Gas Company what fruits might be expected of the Upas.

There is not the remotest possibility of any success being obtained in any of the arts by a nation which thus delights itself in the defilement and degradation of all the best gifts of its God; which mimics the architecture of Christians to promote the trade of poisoners; and imagines

itself philosophical in substituting the worship of coal gas for that of Vesta.[6]

During the late eighteen-fifties he was finishing *Modern Painters*, struggling with the problems of cataloguing and, as an executor, in some way dealing with Turner's artistic property; he was also engaged in the effort to give Oxford a Gothic science museum: but he found time, in a series of lectures, to elaborate his theory of social causation in the fine arts (*The Two Paths* and *A Joy for Ever*) and, as a first step towards practical social activity he taught at the Working Men's College founded by F. D. Maurice and the Christian Socialists. This teaching, together with many applications from amateurs, led him to the production of a drawing book, *The Elements of Drawing*. It is a comparatively short and, for Ruskin, a highly methodical work. It shows how far he had gone from academic ideas in that it recommends neither the antique nor the figure. Pebbles, twigs and leaves are to be the student's inspiration, he is to be subjected to a rigorous and, on the whole, salutary discipline very different from, and far more tonic than, the systematised tricks and technical short cuts of the contemporary drawing-master and far more enlivening and rewarding than the geometrical analyses of South Kensington.

He considered many art educational ventures, some of them fantastic and not wholly serious. He added many pages of social exhortation to the later volumes of *Modern Painters*. But this was not sufficient for his purposes. He wanted to deliver himself of a more directly propagandist message; the result was *Unto this Last*, his first Communist tract.

I use the word Communist advisedly. Ruskin

himself used it when he said: "Indeed I am myself a Communist of the old school—reddest also of the red."[7] This was in the seventh number of *Fors Clavigera* (1872); in the tenth number he added: "I will tell you plainly. I am, and my father was before me, a violent Tory of the old school."[8] The two statements are not incompatible so long as we understand what Ruskin meant by "the old school."

Although Ruskin was anything but a materialist his conception of history is not very far from that which you will find in the *Communist Manifesto* of 1848.

> All social evils and religious errors arise out of the pillage of the labourer by the idler: the idler leaving him only enough to live on (and even that miserably), and taking all the rest of the produce of his work to spend in his own luxury, or in the toys with which he beguiles his idleness.
>
> And this is done and has from time immemorial been done, in all so called civilized, but in reality corrupted, countries,—first by the landlords; then, under their direction, by the three chief so-called gentlemanly "professions", of soldier, lawyer and priest; and, lastly, by the merchant and usurer.[9]

The cure for social evils lay in socialism: but Ruskin seldom used the word, and this for the very important reason that socialism, in his mind, was identified with democracy and republicanism, things which he detested. "Government and co-operation are in all things the laws of life: anarchy and competition the laws of death".

Ruskin, good Tory and good communist that he was, hated liberalism in all its forms. He detested

political freedom in the sense of freedom to buy in the cheapest market and sell in the dearest, freedom to "charge all that the traffic will bear and damn the public," freedom to cheat and to adulterate, freedom to cover the face of England with grimy cities, to pollute her rivers, to darken her skies. These were liberties that he would not tolerate. The business of the State was to control private enterprise, to nationlise land and transport, to regulate the conditions of labour, to divert wealth to land improvement, education and public health.

In his objectives Ruskin was therefore an authoritarian socialist: but he had no sympathy for revolution or even for innovation.

I am by nature and instinct Conservative, loving old things because they are old, and hating new ones merely because they are new.[10]

Nor could he entrust his programme to the masses. The existing order of things was to be condemned precisely because it had made the working classes unfit for such a task.

The rich not only refuse food to the poor; they refuse wisdom; they refuse virtue; they refuse salvation.[11]

He had therefore to look elsewhere for the saviour of society: given his upbringing, it is natural that he should have turned to the gentleman, whom he defined as:

A man of pure race; well bred, in the sense that a horse or dog is well bred. . . .

Gentlemen have to learn that it is no part of their duty or privilege to live on other people's toil. They

have to learn that there is no degradation in the hardest manual, or the humblest servile, labour, when it is honest. But that there *is* degradation, and that deep, in extravagance, in bribery, in indolence, in pride, in taking places they are not fit for, in coining places for which there is no need. It does not disgrace a gentleman to become an errand boy, or a day labourer; but it disgraces him much to become a knave or a thief. . . .

On the other hand, the lower orders, and all orders, have to learn that every vicious habit and chronic disease communicates itself by descent; and that by purity of birth the entire system of the human body and soul may be gradually elevated, or, by recklessness of birth, degraded; until there shall be as much difference between the well-bred and ill-bred human creature (whatever pains be taken with their education) as between a wolf-hound and the vilest mongrel cur. And the knowledge of this great fact ought to regulate the education of our youth, and the entire conduct of the nation. . . .[12]

We have here a refined version of old Mr Ruskin's downright, duke-loving snobbery. We have also an indication of the dilemma in which Ruskin found himself. It might well be argued that society could be saved only by those who had the education and the habits of command that would ensure wise leadership: but supposing the ruling class was itself morally unfit and wholly disinclined for the task of regeneration? This was a difficulty by which Ruskin found himself continually confronted, all the more so because, while unconvinced and uninterested by the policies of the two major parties—he was Marxist in

his belief that economic arrangements were of much more importance than political structures—he also had an aversion to the social pastimes of the rich, the display of gaudy clothes and the slaughter of animals.

Nevertheless, a romantic faith in aristocracy fortified by the teaching of Carlyle—who was indeed a major influence—kept him always in sympathy with the strong. Any tough, resolute autocrat—Radetsky, Napoleon III, Governor Eyre—might command his sympathies and although he could, on occasion, denounce its cruelties, he was usually ready to defend British Imperialism.

Ruskin's indecisions and perplexities are very clearly shown by his attitude to war. He shrank in horror from its barbarity and he saw well enough that the common soldier was the dupe of those who put him into uniform. On the other hand it appealed strongly to his imagination. As a child he played imaginary war games, as an adult he saw the fascination of

the great gentleman's game, which ladies like them best to play at,—the game of War. It is entrancingly pleasant to the imagination. . . .[13]

War brought out just those qualities which he most admired, or thought he admired, in men—courage, loyalty, chivalry, fortitude, these were fine things and he strongly disapproved of any artist who might represent soldiers on the battlefield in a state of blind rage or blind terror.

Those of us who were pacifists in the nineteen-thirties but found ourselves, nevertheless, supporting a war in 1936 may sympathise with Ruskin's agonised dubieties. Ruskin, in the eighteen-sixties, had to endure a British Government which, while plundering

China and Africa, allowed Prussia, by a series of savage assaults, to make herself mistress of Europe.

I hope that this brief adumbration of Ruskin's internal contradictions may give some clue to the nature of his communism and his conservatism. His communism was the communism of Sir Thomas More, his conservatism the conservatism of Strafford. He objects to capitalism both because it oppresses labour and because it menaces aristocracy and he will have none of it—literally none of it—neither its social institutions nor its mechanical tools. He protests against the ugliness of capitalism, against the destruction of that which is old and beautiful and against its replacement by the vulgar, noisome iron-mongery of the machine age. Unlike the modern socialist, who wishes to harness modern industry, he wanted—or half-wanted— to abolish it and return to the past. The qualification is necessary for this aspect of Ruskin's teaching has been exaggerated. Ruskin admitted, though reluctantly, the necessity for railways, although he would not admit the necessity for the threshing machine. He was ready to countenance modern industry so long as it kept its place. A correspondent wrote:

> One more question. Since you disparage so much Iron and its manufacture, may it be asked how your books are printed and how is their paper made? Probably you are aware that both printing and paper-making machines are made of that material.

and received the following reply:

> Sir,—I am indeed aware that printing and paper-making machines are made of iron. I am aware also,

which you perhaps are not, that ploughshares and knives and forks are. And I am aware, which you certainly are not, that I am writing with an iron pen. And you will find in *Fors Clavigera*, and in all my other writings, which you may have done me the honour to read, that my statement is that things which had to do the work of iron should be made of iron, and things which have to do the work of wood should be made of wood; but that (for instance) hearts should not be made of iron, nor heads of wood—and this last statement you may wisely consider, when next it enters into yours to ask questions.[14]

In politics, as in art, Ruskin can hardly be considered an innovator. He owed much to Carlyle, a little, perhaps, to Disraeli, his thought has something in common with Lasalle and he belongs, roughly speaking, to that category of feudal socialists about whom Marx was so terribly rude in the *Communist Manifesto,* Ruskin, in fact, was a latecomer amongst the socialist thinkers of the mid-nineteenth century. Necessarily and fatally so; for his social thinking was almost certainly arrested by the violence of 1848, for which he had no sympathy, and in consequence he arrived at his socialism at a moment when Chartism was moribund and liberalism ascendant. By the time of the Socialist Revival of the eighteen-eighties Ruskin was too ill and too agitated to be an effective political force. He was therefore condemned by the nature of his beliefs and by the accidents of history to preach to those who would not listen.

Ruskin, says Mr Forster, though "full of high purpose, full of beauty, full even of sympathy and the love of men" speaks with "the voice of one who

had never been hungry and dirty, and had not guessed successfully what dirt and hunger are."[15] This is perhaps rather a severe criticism but it contains a measure of truth. Ruskin was a romantic socialist just as he was a romantic critic; he is interested in violent contrasts rather than in intermediate subtleties. He is moved by cases of scandalous injustice or destitution but he cannot understand the insecurity of the man on the margin of poverty. St Martin divided his cloak with a beggar—and it is not hard to imagine Ruskin doing likewise—but we do not have it on record that the saint ever assisted a bookmaker suffering from a run of popular wins, neither would Ruskin have done so.

Having, however, made this reservation and whatever other reservation the reader may think proper as to the wisdom of Ruskin's political doctrines, it is impossible not to stand amazed and admiring before the spectacle of a critic who, with very little preliminary reading and no economic education, ventured to assault the most cherished economic principles of his age and who, despite the "invincible ignorance" that he found in all classes, continued to speak what he believed to be the truth until at last he could speak no more.

In this arduous task he lost what had previously been his chief support, for Ruskin's conversion to communism was accompanied by an evolution of thought more private but for him even more momentous. From about 1860 Ruskin ceased to believe in any particular form of Christianity.

The duality of mind which we have noticed in Ruskin's approach to politics may also be found in his attitude to religion. He was intensely devout and intensely Protestant. As we have seen, he was

still, to all appearances, securely enclosed within the evangelical pew when he wrote *The Seven Lamps of Architecture* in 1849. In 1851, in his pamphlet *The Construction of Sheepfolds* he was a determined Protestant advocating a common front against Rome. And yet his enquiring and scientific mind had for long been at work. When he had just left Oxford he argued reluctantly, but firmly, that death, being a biological necessity, must have existed in the Garden of Eden before the Fall and, in the year after his *Construction of Sheepfolds*, he was privately expressing to his father his doubts as to the immortality of the soul.

In the fourth volume of *Modern Painters* Ruskin goes out of his way to prove the existence of God. When examining the structure of the Alps he points out that it does not usually allow avalanches to descend very far into the valleys and he comments:

> It can hardly be necessary to point out the perfect wisdom and kindness of this arrangement, as a provision for the safety of the inhabitants. . .[16]

Or, take the following passage from the same volume:

> Had granite been white and marble speckled (and why should this not have been, but by the definite Divine appointment for the good of man?), the huge figures of the Egyptian would have been as oppressive to the sight as cliffs of snow, and the Venus de' Medici would have looked like some exquisitely graceful species of frog.[17]

One is reminded of the preacher who pointed to the forethought of God in making the rivers of France pass through her principal cities and may deduce, I

think, that Ruskin was whistling to keep his spirits up. His difficulties were in part intellectual, in part moral. The eighteen-fifties were difficult and dangerous years for those who, like Ruskin, depended upon the imposing but fragile armour of Holy Writ. But I think that it was the moral problems which, in the end, drove him out of the Church of England. He was worried, as any sensitive Christian must be, by the idea of damnation. Speaking of medieval belief he writes:

> I wonder at this one thing only; the acceptance of the doctrine of eternal punishment as dependent on accident of birth, or momentary excitement of devotional feeling. I marvel at the acceptance of this system (as stated in its fulness by Dante) which condemned guiltless persons to the loss of heaven because they had lived before Christ. . . .[18]

This was bad enough, but perhaps worse was the continuing hatred between Christians of different sects, a hatred which seemed to place the unbeliever in a position of moral superiority.

> those among us who may in some measure be said to believe, are divided almost without exception into two broad classes, Romanist and Puritan; who, but for the interference of the unbelieving portions of society, would, either of them, reduce the other sect as speedily as possible to ashes. . . .[19]

Gradually he found that he was no longer committed to Protestantism. The final disillusionment took an aesthetic form; he found himself disgusted by Protestantism in a chapel of that Waldensian sect which, through its antiquity and through association with the poetry of Milton has the strongest claims on the

77

Puritan imagination. Writing from Turin in 1858 he expressed himself thus:

> I went to the Protestant church...—and very sorry I was that I did go. Protestantism persecuted, or pastoral in a plain room, or a hill chapel white-washed inside and ivied outside, is all very well; but Protestantism clumsily triumphant, allowed all its own way in a capital like this, and building itself vulgar churches with nobody to put into them, is a very disagreeable form of piety. Execrable sermon—cold singing. A nice-looking old woman or two . . .; three or four decent French families; a dirty Turinois here and there, spitting over large fields of empty pew . . .[20]

Thereafter he ceased to call himself a Protestant. He ceased to believe firmly in a future life, he began to paint on Sundays and to question the historical character of the Old Testament. Nevertheless Ruskin remained intensely religious. He was theistic as other men are fat; belief in God was an essential part of his nature. He never accpeted the Darwinian theory and he never questioned the Christian ethic. His quarrel with the Churches was that they were insufficiently religious just as his quarrel with the upper classes was that they were insufficiently aristocratic.

In one way this break with the religion of his youth must have been a relief. From about 1845 until 1850 Ruskin was in the difficult position of being a Puritan art critic; the difficulty was rendered greater by his particular affection for that school which, beyond all others, has given an enthusiastic account of worldly splendour and carnal luxury. Titian and Veronese set him a problem which he resolves in a manner which may not carry universal conviction:

But the mere power of perfect and glowing colour will, in some sort, redeem even a debased tendency of mind itself, as eminently the case with Titian, who, though often treating base subjects, or elevated subjects basely, as in the disgusting Magdalen of the Pitti Palace, and that of the Barberigo at Venice, yet redeems all by his glory of hue, so that he cannot paint altogether coarsely: and with Giorgione, who had more imaginative intellect, the sense of nudity is utterly lost, and there is no need nor desire of concealment any more, but his naked figures move among the trees like fiery pillars, and lie on the grass like flakes of sunshine. With the religious painters, on the other hand, such nudity as they were compelled to treat is redeemed as much by severity of form and hardness of line as by colour, so that generally their draped figures are preferable.[21]

This was all very well, but it did not satisfy him entirely. He had once favoured the more austere Quattrocento: now he found himself turning to the great Venetians of the Renaissance; it was during that sojourn in Turin which ended his Protestantism that he made the following equally momentous discovery:

Titian and Veronese are always noble; and the curious point is that both of *these* are sensual painters, working apparently with no high motive, and Titian perpetually with definitely sensual aim, and yet invariably noble; while this Gentileschi is perfectly modest and pious, and yet base. And Michael Angelo goes to even greater lengths, or to lower depths, than Titian; and the lower he stoops, the more his inalienable nobleness shows itself. Certainly it seems intended that strong and frank

animality, rejecting all tendency to asceticism, monachism, pietism, and so on, should be connected with the strongest intellects. Dante, indeed, is severe, at least, of all nameable great men; he is the severest I know. But Homer, Shakespeare, Tintoret, Veronese, Titian, Michael Angelo, Sir Joshua, Rubens, Velasquez, Correggio, Turner, are all of them boldly Animal. Francia and Angelico, and all the purists, however beautiful, are poor weak creatures in comparison. I don't understand it; one would have thought purity gave strength, but it doesn't. A good, stout, self-commanding, magnificent Animality is the make for poets and artists, it seems to me.[22]

Here indeed is a problem, but Ruskin meets it with characteristic ingenuity. The moral measure of an artist was to be gauged, not by his unconsciousness of sin, but by his ability to trascend it. The greatness of Titian and Shakespeare lay precisely in their ability to see life steadily and see it whole, to converse with and to record the flesh and the Devil and yet to emerge unscathed from that dangerous interview. The simple untroubled fidelity of an Angelico or a Bellini might produce art as limpid and lovely as the prattle of a good child: but, like children, such artists could never attain the fearful power of those who have gone out into the world to meet Apollyon. It was a pretty theory, but one which Ruskin himself was to abandon.

REFERENCES

1. *Unto this Last*, XVII. 32.
2. *F.C.* [letter 2], XXVII. 95.
3. Bevington: *The Saturday Review* (Columbia 1941), p. 135.
4. *The Crown of Wild Olive*, II: XVIII. 453.
5. *M.P.* [vol. 5], VII 446—8.
6. *S.V.*, Preface to the Third Edition, IX. 13.
7. *F.C.* [letter 7], XXVII. 116.
8. *F.C.* [letter 10], XXVII. 167.
9. *F.C.* [letter 84], XXIX. 294—5.
10. Letter to Henry Acland, M.D., 27 Apr. 1856, XXXVI. 239.
11. *Unto this Last*, XVII. 107.
12. *M.P.* [vol. 5], VII. 343—7.
13. *The Crown of Wild Olive*, XVIII. 408.
14. *F.C.* [letter 14], XXVII. 258—9.
15. E. M. Forster, *Howard's End*, Ch. VI.
16. *M.P.* [vol. 4], VI. 208.
17. *M.P.* [vol. 4], VI. 143.
18. *M.P.* [vol. 5], VII. 300.
19. *M.P.* [vol. 3], V. 322.
20. To his father, 4 Aug. 1858, XXXVI. 287—8.
21. *M.P.* [vol. 2], IV. 195—6.
22. Notes on the Turin Gallery quoted in the Introduction to *M.P.* [vol. 5] by Wedderburn and Cook, VII. Xl.

Chapter 4

SESAME AND LILIES

What we may perhaps call the climacteric of 1858—64—the period in which Ruskin consolidates his political theory, loses his religion and revises his aesthetics—is notable also for a development of another kind. Ruskin fell in love. It was the third and most serious emotional adventure of his life, none the less serious because, when they first met, Rose La Touche was barely ten years old and Ruskin was forty; there was, therefore, at the outset no question of marriage, nor—at any conscious level—of carnality. These circumstances did not, however, prevent Ruskin from feeling what can only be described as passion:

Rose, in heart, was with me always, and all I did was for her sake.[1]

English middle-class society in 1860 was, no doubt, prudish: but it did not have the nasty twentieth-century habit of overturning screens. Ruskin, if he pleased, might then live on terms of sentimental intimacy with an entire girls' school—in fact he did precisely this and the modern reader knows not whether to blush or snigger at the romps and oglings, toyings and teasings which were conducted with perfect candour under the benevolent eye of the head-mistress at Winnington. He was licensed, as the Rev. C. L. Dodgson was licensed, to enchant pretty ten-year-old maidens and to vanish with them into a private wonderland. Ruskin, indeed, flirted with that same Alice and the censorious world, blinded by its own proprieties, connived at these Platonic seductions.

If gossip looked for a meal of scandal it would
have attempted to make it at the expense of Mrs La
Touche, the charming and fashionable mother of
Ruskin's *inamorata*; but it would have earned no
more than a barmecide feast: Ruskin enjoyed the
company of beautiful women, of Lady Canning, Lady
Waterford, Mrs Rossetti and Mrs Burne-Jones, Lady
Trevelyan and Mrs Cowper Temple: but in these
relationships there was no hint of impropriety. He
admired their beauty and, less reasonably, their
watercolours; they, for their part, enjoyed his con-
versation, his charm, his gentle courtesy and his
admiration—also, I suspect, a feeling of safety. From
him, they must surely have sensed, they had nothing
to hope or to fear.

Rose La Touche, we may suppose, was as safe as
they. Ruskin set himself to educate her, to play with
her, to be at once her master and her friend, to
develop her already lively intelligence. She was his
"Rosie, pet, and Rosie, puss," his "Rosie posie"; he
was her "St. Crumpet" or, more briefly, "St. C.". It
was all very delightful for she was a lovely, amusing
and amiable girl. In the intervals of trying to reform
this world and to understand the next he must have
found in the company and correspondence of Rose
some moments of pure, rare and unexpected felicity.

Naturally, inevitably, the idyll came to an end;
Rose grew up. If only Ruskin could then have ceased
to love her, if only, like Lewis Carroll, he could have
then found some new houri of the nursery. Unfor-
tunately, he was too constant; as with Effie, so with
Rose, he continued to love the child after she had
become a woman. When she was seventeen and he
nearly fifty, he proposed. This marked the beginning
of a long series of separations, short reunions, quarrels,

reconciliations and *démarches* which lasted for ten miserable years.

Everything was against any possibility of happiness. Rose was intensely religious, religious to the point of insanity, and she was horrified by Ruskin's doubts; she was sickly, distrustful, irresolute; at times she irritated him profoundly. But, above all, there was the great difficulty presented by Ruskin's past history. Mrs La Touche, understandably, felt that Ruskin would not make a satisfactory husband. She applied to lawyers who told her, erroneously, that he was not free to marry after he had been declared impotent by a court of law; she also wrote to Mrs Millais who replied that her first husband was "quite unnatural," that he had used her very ill and that the best that could be said for him was that he was insane.

Ruskin's admirers have blamed Effie for writing this letter. She should, it has been said, tactfully have declined to discuss the matter. There is some justice in these reproaches. Effie was, to put it vulgarly, "getting her own back" and her letter contains what appears to be a gratuitous falsehood. Nevertheless it should be remembered that she knew what it was like to be married to Ruskin and we do not; if she believed a half of what she wrote, she had a strong moral case for doing her best to prevent another young woman from sharing her experience. Undoubtedly her letter did more than anything else to stop the match. Whether such a marriage, a marriage between an elderly man and an invalid girl, one of them almost certainly impotent, the other poised upon the brink of insanity, could have been happy may well be doubted.

While this tragic relationship was developing

another hardly less unhappy was brought to its close.
Ruskin's father died in 1864. John James Ruskin had
achieved much in his life, he had made a great fortune
and he had begotten a son who was famous, even
though he was not famous in quite the way that John
James had hoped for, and best of all, John was re-
ceived and welcome in high society. But in spite of—or
perhaps because of—their intense mutual affection,
father and son became estranged and even embittered.
John James was distressed by Ruskin's religious diffi-
culties, and, perhaps even more, by his economic
heresies. These were ills that might readily be cured
by affection, but, at last, affection itself was called
in question:

—you fed me effeminately and luxuriously to that
extent that I actually now could not travel in
rough countries without taking a cook with me!—
but you thwarted me in all the earnest fire and
passion of life. About Turner you indeed never
knew how much you thwarted me—for I thought it
my duty to be thwarted—and it was the religion
that led me all wrong there; if I had had courage
and knowledge enough to insist on having my own
way resolutely, you would now have had me in
happy health, loving you twice as much (for,
depend upon it, love taking much of its own way, a
fair share, is in generous people all the brighter for
it), and full of energy for the future—and of power
of self-denial: now, my power of *duty* has been
exhausted in vain, and I am forced for life's sake to
indulge myself in all sorts of selfish ways, just
when a man ought to be knit for the duties of
middle life by the good success of his youthful life.
No life ought to have *phantoms* to lay.[2]

I am convinced that Ruskin wrote this letter without any intention of being cruel, but it is hard to imagine a more venomously innocent letter from a son to a doting parent.

Four months later John James died. Mrs Ruskin survived him by seven years. She was always a tyrant: as she grew older she grew even more despotic and cantankerous. Ruskin invariably accepted her public rebukes, however unreasonable, with the gentle and submissive deference of an affectionate son: but he very sensibly arranged, by foreign travels and English excursions, that his temper should not be tried too continually.

His father's death placed Ruskin in command of a very considerable fortune. He had, hitherto, lived upon an allowance. John James never consulted his son on any matter of business and kept him in financial tutelage. Entering thus ill-equipped into the possession of great wealth Ruskin managed, in a space of about twenty years, to spend or lose everything. He did this partly by bad management, partly by extravagance, but very largely by reason of benevolent credulity and sheer generosity. Luckily for him, his books were selling so well by the time his capital was gone that he was never poor.

During the eighteen-sixties and eighteen-seventies there were few extravagances and still fewer charities that he could resist. He bought diamonds and gave them to museums, missals and cut them up for friends, he put a tenth part of his fortune into a scheme for establishing an English Utopia, he purchased slum property and placed it in the firm yet charitable hands of Octavia Hill, he set the unemployed to sweeping the streets and his family retainers to dispensing tea to the poor in packets, he tried to buy

an Alp, he did buy a supposed Titian, he established a drawing school at Oxford, he gave away collections of pictures and minerals, he subsidised a girls' school, he made C.A. Howell—who was a scoundrel—his almoner and through this agency disbursed money to anyone who could tell a sufficiently affecting story of undeserved misfortune. On one occasion, finding a little girl who had nowhere to play, he promptly bought her a field. Altogether, he probably got better value for his money than do most very rich men.

Having finished *Modern Painters* Ruskin made no further attempt to write another long prose work. He expressed himself by means of comparatively short articles on art which usually dealt with politics or in political tracts which dealt largely with art, or by means of essays on geology, ornithology, or botany which dealt with both art and politics.

From 1854, when he first spoke to an Edinburgh audience, the lecture became to an increasing extent his favourite form of expression. The decade 1860—70 saw, in addition to the purely political essays, four volumes of lectures. These he collected and published under increasingly recondite titles: *Sesame and Lilies* (1865), *The Crown of Wild Olive* (1866), *The Cestus of Aglaia* (1866), *Queen of the Air* (1869).

Ethics of the Dust (1866) is also of this period and is, I think, his worst book. This is not a lecture but a series of morally improving lessons in geology given to the girls at Winnington School and written in the form of a dialogue. It would not have been a very good book even if it had been more wisely planned. Even Ruskin's charm is not capable of making his half-jocular, half-tender descriptions of mineral formations endurable:

Here, for instance, is a good garnet, living with good mica; one rich red and the other silver white: the mica leaves exactly enough room for the garnet to crystalize comfortably in; and the garnet lives happily in its little white house; fitted to it, like a pholas in its cell. But here are wicked garnets living with wicked mica. See what ruin they make of each other! You cannot tell which is which; the garnets look like dull red stains on the crumbling stone.[3]

Graham Hough has said that this "avuncular play-fulness" is Ruskin's besetting vice, and reading *Ethics of the Dust* it is impossible not to agree with him: but here we have the additional vexation of being compelled to listen to Ruskin in dramatic form. In argument, he is incapable of bringing another person to life. Nearly always, in his best writing, he speaks in the first person or at least we divine the man himself close behind the argument. So that, whether we agree or disagree, we feel ourselves always in the presence of a fascinating personality. It was perhaps this literary egotism that made him so successful as a lecturer. He was from the first effective but after about 1860 he reached the top of his form. The printed texts do not always represent that which his audience heard. He would depart from it to follow some unpremeditated line of thought—although the texts themselves are sufficiently discursive. Nor can we do more than guess at the power of his delivery, the charm of his address, the terror of his earnestness in exhorting the nation to retrace its steps, the great, long, sustained, mounting *crescendi* with which he interpreted the sonorous music of his paragraphs. In conversation he was invariably gentle; his written

words could be savage; but in the lecture theatre the terrible demon that dwelt in his pen could walk hand in hand with the angel that lived in his countenance.

In an age of great spellbinders—Bright, Gladstone, Tennyson, Disraeli and Spurgeon—he had no superior and few peers. He could hold an audience silent, move it to tears, laughter or ravishment and do so while telling it the most absurd, the most paradoxical, the most devastatingly truthful things about itself.

All this we may infer from the accounts of his lectures. From the text we gain an impression that is, necessarily, less overwhelming. He would begin on a note of self-deprecating courtesy. A statement of his main theme might follow—but on this you cannot depend—then some new, arresting or challenging restatement of what had hitherto seemed a commonplace, or a sudden burst of self-revelation—and then, almost anything might happen. Here, for instance, in *The Queen of the Air*, a study of Greek mythology, he describes a bird:

It is little more than a drift of the air brought into form by plumes; the air is in all its quills, it breathes through its whole frame and flesh, and glows with air in its flying, like a blown flame: it rests upon the air, subdues it, surpasses it, outraces it;—*is* the air, conscious of itself, conquering itself, ruling itself.[4]

And in contrast to this, which is to all intents and purposes poetry, we find, in the same group of lectures, a cogent argument upon the relation of money to goods.

The lecturer bloweth where he listeth, but the chances are that he will end by bringing you to a highly moral conclusion:

With the multitude that keep holiday, we may perhaps sometimes vainly have gone up to the house of the Lord, and vainly there asked for what we fancied would be mercy; but for the few who labour as their Lord would have them, the mercy needs no seeking, and their wide home no hallowing. Surely goodness and mercy shall *follow* them, *all* the days of their life; and they shall dwell in the house of the Lord—FOR EVER.[5]

Did Ruskin make his antithesis clear by dwelling on the *Holi*day and the *hall*owing? Did he stress the repetition of "vainly" and emphasise "fancied"? We cannot tell, but we can see very well that he is ending upon a note of high solemnity. What we do not so easily perceive is the gaiety of so much of his text. I once attempted to write a parody of Ruskin, an addition to the lecture on *"Traffic"* which is published in *The Crown of Wild Olive*. A talented actor read my pastiche, together with some paragraphs from Ruskin's original lecture. This, though humiliating, was instructive. I had kept as close as I could to the master's lecturing style, but I was immediately aware that I had caught very little of his wonderful felicity of phrasing, the perfect tempo of his arguments: but what chiefly appeared was the unrelieved solemnity of my prose when compared with his. Again and again he gives his interpreter an opening for comic emphasis and I have little doubt that his audiences were kept in a state of intermittent merriment. This is indeed one of the chief engines of a skilful public speaker who has a serious message to impart. He needs laughter, not only to give a sharper relief to his arguments, but also in order to keep his audience perpetually alert and receptive.

In the eighteen-seventies, when he was at Oxford, Ruskin found that, in order to talk about art, he needed something more than verbal illustrations in order to make his meaning clear. The projector was then in its infancy: but by bringing actual examples on to the platform he could illustrate his words, point to beauties or defects that lay before his audience, and by sudden and unexpected juxtapositions add force to his arguments. In all this he was looking forward to the techniques of the modern lecturer with his two screens and twin lanterns: but in some respects he would go further, as for instance when he would seize a brush and work rapidly upon the glazed surface of a picture illustrating his meaning with a force unattainable by the written or spoken word.

The most celebrated of Ruskin's volumes of lectures is that entitled *Sesame and Lilies* and of these the most important is probably that entitled "*The Mystery of Life and its Arts.*" It is an unusually systematic production and one which sums up Ruskin's moral and intellectual position in 1868. "I put into it," said Ruskin, "all that I knew"[6]; this he did for the very good reason that he was addressing himself not simply to a large Dublin audience, but to one member of that audience, Rose La Touche.

Nominally this was a lecture on art, but in fact it was an essay in pessimism. He begins by talking about himself and takes a very poor view of his subject. He describes his struggle to obtain recognition for Turner in which, as it now seemed to him, he had done no more than make a reputation for himself as a man who could say pretty things about painting. Then he considers his endeavours in the service of architecture, which had indeed inspired some architects but had nevertheless miscarried. Of the Venetian Gothic of his age he says:

sometimes behind an engine furnace, or a railroad
bank, you may detect the pathetic discord of its
momentary grace, and, with toil, decipher its
floral carvings choked with soot.[7]

In fact, as an apostle of art, he had failed; and so
had the artists. He restated his central argument:
"the arts can never be right themselves unless their
motive is right." And yet there were plenty of incom-
petent painters who were inspired by high moral
purposes while the competent practitioner was only
too ready to betray the moral ends that he should
serve. Here indeed was a mystery, a mystery analo-
gous to that of those men—the great majority—who
proclaimed the truths of religion and then disregarded
them, who acted as though there were neither Heaven
nor Hell to punish them. But indeed, do we really
believe in Heaven and Hell? Milton's account is wholly
unconvincing while Dante, after all, is concerned
only with "one dear Florentine maiden." Such are
the mysteries of life, and, if we go further and ask the
great poets to reveal its purposes we find that Homer
has nothing better to give us than an angry young
man in a fit of the sulks while Shakespeare shows us
individuals struggling against a blind, undiscriminating
fate. Ruskin then turns to the practical men, what
can they offer us? He answers with a parable, in
which he compares them to children left to play by
themselves in a garden.

In the garden were all kinds of flowers; sweet,
grassy banks for rest and smooth lawns for play;
and pleasant streams and woods; and rocky places
for climbing. And the children were happy for a
little while, but presently they separated them-
selves into parties; and then each party declared it

would have a piece of the garden for its own, and that none of the others should have anything to do with that piece. Next, they quarrelled violently which piece they would have; and at last the boys took up the thing, as boys should do, "practically", and fought in the flower beds till there was hardly a flower left standing; then they trampled down each other's bits of the garden out of spite; and the girls cried till they could cry no more; and so they all lay down at last breathless in the ruin, and waited for the time when they were to be taken home in the evening.[8]

Ruskin proceeds to enlarge his parable, taking us from international relations to the social structure; here again with all the wealth of the world around them the "children" spend their time miserably squabbling over tokens which, as they know only too well, will be taken from them at bedtime.

Finally he turns from the governors of mankind to the governed—the workers. They, perhaps, may have something of value to say but you cannot understand them unless you are one of them. They are inarticulate:

The moment a man can really do his work he becomes speechless about it. All words become idle to him—all theories.[9]

This, naturally, brings him back to the artist and the arts. He tells his audience of the kind of art-critical entertainment that he might have provided.

I could talk to you about moonlight, and twilight, and spring flowers and autumn leaves, and the Madonnas of Raphael—how motherly! and the Sibyls of Michelangelo—how majestic! and the Saints of Angelico—how pious! and the Cherubs of

Correggio—how delicious! Old as I am I could play you a tune on the harp yet, that you would dance to. But neither you nor I should be a bit the better or wiser. . . .[10]

Such criticism is useless, the only criticism worth listening to is the criticism that hurts. In order to show his Dublin audience what he means he provides a hint of it. Had they ever considered how it was that Irish painting, at one time so flourishing, had petered out in the eighth century? He would tell them, as he had told a Cambridge audience in 1858; their art had foundered because it was geometric and conceptual. The Irish draughtsmen had been content to represent nature by means of symbols which for all their imperfection were so rigid as to leave no room for deviation—hence for improvement. Their art was therefore "incorrigible," unlike the drawing of the Lombard illustrators which being hesitant in style was corrigible and therefore open to improvement. Did not this, he continued,—not without a certain hardihood—point to something stubborn and unbiddable in the Irish character? He hastened to add that, in their disputes with the English, the Irish usually had right on their side; nevertheless the criticism had been made.

From strictures upon the Irish, Ruskin returned to the less invidious task of censuring the world in general. He pointed to the simple facts of poverty; people were not properly fed or clothed or housed—this was intolerable and something should be done about it. He appealed to religious people to put their religion into practice, he besought atheists at least to make the best of *this* world. Then he pointed with shrewd insight to the great difficulty that lies in the way of any social reform. Men would give their

treasure for a cause and give generously:

> yes, and life, if need be? Life!—some of us are
> ready enough to throw that away, joyless as we
> have made it. But *"station"* in Life—how many of
> us are ready to quit *that*?[11]

Perhaps no nineteenth-century thinker saw more
clearly the importance of status in social affairs. Will
none of us, he asked, "take so much as a tag of lace
off their footmen's coats, to save the world"?[12]

Ruskin's own sense of social status was keen enough
to make him understand the difficulty, but he was
not so clear—nor is anyone—in seeing how it is to be
surmounted. He ended therefore with a rather vague
and general plea for regeneration.

In his penultimate paragraph he turns suddenly to
one person whom he thought to be in the audience,
and although he speaks, of course, in general terms
she who had made religious scruples a reason for
keeping him at arms' length could not have doubted
that the following words were meant for her:

> You may see continually girls who have never
> been taught to do a single useful thing thoroughly;
> who cannot sew, who cannot cook, who cannot
> cast an account, nor prepare a medicine, whose
> whole life has been passed either in play or in pride;
> you will find girls like these, when they are earnest-
> hearted, cast all their innate passion of religious
> spirit, which was meant by God to support them
> through all the irksomeness of daily toil, into
> grievous and vain meditation of the great Book, of
> which no syllable was ever yet meant to be under-
> stood but through a deed; all the instinctive wisdom
> and mercy of their womanhood made vain, and the

glory of their pure consciousness warped into fruit-
less agony concerning questions which the laws of
common serviceable life would have either solved
for them in an instant, or kept out of their way.
Give such a girl any true work that will make
her active in the dawn and weary at night, with the
consciousness that her fellow creatures have indeed
been the better for her day, and the powerless
sorrow of her enthusiasm will transform itself into
a majesty of radiant and beneficent peace.[13]

So much for Rose La Touche.

Unfortunately Rose was *not* present and although
she did no doubt read *Sesame and Lilies* there is no
reason to suppose that it cured her of biblical specula-
tion and intolerance or turned her to practical Christ-
ianity. In fact there is, I believe, no evidence to show
that anyone's life was changed by this lecture. People
were no doubt interested, bothered or intrigued by it:
but I suspect that Mallock, who is his *New Republic*
draws a striking picture of Ruskin—"Mr. Herbert"—
comes near to the general reaction of polite society
when he puts these words into the mouth of one of
his characters:

What a dreadful blowing up Mr. Herbert gave us
last night, didn't he? Now that you know, I think
is all very well in a sermon, but in a lecture, where
the things are to be taken more or less literally, I
think it's a little out of place.[14]

We know that such a commentator will easily for-
get or disregard anything that might otherwise be too
unpleasant for consideration. The audiences that
came to listen to Ruskin in Dublin or Bradford or
Manchester must largely have been composed of

people who could in the same way ignore that which they wanted to ignore. To be effective Ruskin needed a different public, a public that was young and receptive and adventurous, or a public so much inclined to social experiment that it would not be frightened by new ideas—in a word he needed the students and the workers and after 1870 he was able to address them.

REFERENCES

1. P., XXXV. 533.
2. Letter to his father, 16 Dec. 1863, XXXVI. 461.
3. *Ethics of the Dust*, XVIII. 279.
4. *The Queen of the Air* II, XIX. 360.
5. *Lectures on Art, The Relation of Art to Morals* XX. 94.
6. Preface to Vol. XVIII. lviii.
7. *S.L., The Mystery of Life and its Arts* XVIII. 150.
8. *Ibid* 163—4.
9. *Ibid* 167.
10. *Ibid* 169.
11. *Ibid* 181.
12. *Ibid.*
13. *Ibid* 186.
14. Mallock, *The New Republic* (1877), p. 365.

Chapter 5

OXFORD AND *FORS CLAVIGERA*

On 8 Feb. 1870 the lecture theatre of the Natural
History Museum at Oxford, one of the most striking
products of his teaching, was filled with those who
came to hear Ruskin's inaugural address as first Slade
Professor at the University. Presently the multitude
became so vast that the audience had to adjourn to
the Sheldonian.

The lecture itself was one of Ruskin's more sober
utterances. The occasion demanded solemnity, and
the speaker, looking back perhaps to that equally
memorable day a hundred years earlier when the
President of the new Royal Academy delivered the
first of his Discourses, celebrated the admission of the
Fine Arts to Oxford in phrases which recall the steady
periods of Reynolds.

The Chair of Fine Art, founded by Felix Slade,
gave Ruskin the chance to return to his old university
and to realise a dream, one that others had also
dreamed, of giving the youth of the governing classes
a measure of taste that would complete their edu-
cation and ensure that England would no longer
be governed by men who, in matters of art, were
barbarians.

To this end Ruskin delivered a great number of
lectures on art, and on much else besides, lectures
which have been published as *Lectures on Art* and
Aratra Pentelici, both of 1870, *Lectures on Land-
scape* (1871), *Ariadne Florentina* and *The Eagle's
Nest* (1872), *Val d'Arno* (1873) and, after a pause
when he was ill, *The Art of England* (1883). His

98

writings[1] of this period have not been accepted with enthusiasm by modern critics. "They contribute little or nothing to the theoretical work of the fifties," writes Wilenski. "They are the work of one who has long been unable to react to contemporary artistic activity."[1] Dr Evans, though less sweeping, is hardly less disparaging. I want here to suggest that Ruskin's later criticism, despite grievous faults and eccentricities, deserves closer attention and that in fact it was at this period, and this period only, that he became an innovator. First, however, it may be useful to look at the purposes and conditions of his work at Oxford.

Ruskin's lectures were attended by a large and enthusiastic audience and he had an excellent opportunity for advancing his moral and aesthetic ideas. He did indeed make disciples, notably his biographer Collingwood and his editors Wedderburn and Cook. Arnold Toynbee and, perhaps less comfortably, Lord Milner, sat at his feet. But Ruskin wanted to do more, he wanted the practice of art to have its place in the life of the University. He established and endowed a drawing school, which still exists, but he could not fill it as he could fill the lecture theatre; young ladies came but not undergraduates, nor would the University include the practice of art in its teaching. Ruskin also proposed to draw the young men to occupations more useful than knocking a ball about or trifling upon the river; a true disciple of Rousseau and a true comrade of Tolstoy, he set his young admirers to the building of a road.

The Hinksey Road at once became a joke and, as Ruskin himself remarked, it was "probably the worst road in the three kingdoms."[2] One who worked upon it has said:

The Oxford Road failed, partly because of the soil, partly because of the laziness of the undergraduates, and partly because Mr. Oscar Wilde would insist on stopping and lecturing upon the beauties of the colour of the soil that turned up.[3]

Such unacademic adventures must have caused some amusement and some disquiet: but the chief cause of concern at Oxford was Ruskin's habit of telling what he believed to be the truth. As private grief and public indignation worked increasingly upon his fretted mind Ruskin's behaviour in the lecture room became increasingly eccentric. He did not tread, he stamped hard and deliberately upon the moral and social corns of Oxford. He attacked Protestantism and capitalism, modern society and modern science, his manner became more and more eccentric; when he objected to a performance of Mendelssohn's *Oh for the Wings of a Dove*, he danced across the platform waving his academic wings and chanting wildly.

This growing folly affects his criticism and sometimes makes it hard to read, and yet there is much in these later pages that deserves to be considered with attention. In *Aratra Pentelici* he gives an extremely perspicuous account of the art of sculpture and, for the first time, looks seriously at Greek art. *Lectures on Landscape* is in the main a restatement of *Modern Painters*; in *The Art of England* he assesses the Pre-Raphaelites and his criticism of Burne-Jones contains some of his most convincing writing on art.

But the most striking, and scandalous, essay of his last period is *The Relationship between Michael Angelo and Tintoret*. Ever since he had ventured into the general field of European art Ruskin had, I think, considered Michelangelo with admiration rather than

100

enthusiasm. He is, in his earlier writings, respectful, but Ruskin could never love the great master of the nude and the great adversary of colour. Now in 1871 he came to grips with his opponent.

Michelangelo, he believed, stands at the crisis of Italian art; before his time all was sweetness and light, and Ruskin takes Giovanni Bellini as the type of the artist of this happy age:

Then Raphael, Michael Angelo, and Titian, together bring about the deadly change, playing into each other's hands—Michael Angelo being the chief captain in evil; Titian, in natural force.

Then Tintoret, himself alone nearly as strong as all three, stands up for the last fight, for Venice and the old time. He all but wins it at first; but the three together are too strong for him. Michael Angelo strikes him down; and the arts are ended. "Il disegno di Michael Agnolo", that fatal motto was his death warrant.[4]

Thus he announces his argument; he proceeds, with consummate art, to justify it. He begins with Bellini—who is to serve as a foil for all the rest; what power he has, but with what restraint he uses it. What a workman he is and with what supernal tranquillity he works.

Bellini's angels, even the youngest, sing as calmly as the Fates weave.[5]

He can draw the human body but he does not abuse his power; he knows that the soul of man is in his face. In his work there is neither vice nor pain; even when a saint is killed there is in his face only resignation and the faintness of death, not pain. And now what do we find in Michelangelo? Bad workmanship

(his frescoes blacken and perish), violence, figures flying—falling—striking—or biting, the body not the soul the centre of interest, the face shadowed, foreshortened, backshortened and despised among labyrinths of limbs, and mountains of sides and shoulders, evil, sensual passions, vice or agony, the wrath of the *Dies Iræ*, not its justice.[6]

It is only in his preoccupation with the body that Michelangelo resembles the Greeks, but they, like Correggio and Tintoretto:

> learn from the body, from the living body, and delight in its breath, colour, and motion.
>
> Raphael and Michael Angelo learned it essentially from the corpse, and had no delight in it whatever, but great pride in showing that they knew all its mechanism; they therefore sacrifice its colours, and insist on its muscles, and surrender the breath and fire of it for what is—not merely carnal,—but osseous. . . .[6]

If we look carefully we shall find that Michelangelo's facial types are gross and ugly, he shirks difficulties, he uses drapery to conceal ineptitude, he is incapable of intellectual drawing.

> The waves of hair in a single figure of Tintoret's (the Mary Magdalen of the *Paradise*) contain more intellectual design in themselves alone than all the folds of unseemly linen in the Sistine chapel put together.[7]

As for his *Last Judgment* which we have been told is the most sublime picture in existence, what does it convey? Nothing save fear, there is no lesson here, no sympathy. It may appal but it does not chasten or purify and when you reflect upon it you find it empty rhetoric.

All that shadowing, storming and coiling of his, when you look into it, is mere stage decoration, and that of a vulgar kind. Light is, in reality, more awful than darkness—modesty more majestic than strength; and there is truer sublimity in the sweet joy of a child, or the sweet virtue of a maiden, than in the strength of Antæus, or thunder-clouds of Ætna.[8]

Ruskin then turns from the Florentine Doom to the Venetian Paradise of Tintoret and by an easy transition, to one of his usual perorations in which he bids us look heavenwards.

As may be imagined, this thumping denunciation staggered a good many people. The first to be staggered was Edward Burne-Jones:

"He read it to me," said the painter, "just after he had written it, and as I went home I wanted to drown myself in the Surrey Canal or get drunk in a tavern—it didn't seem worth while to strive any more if he could think and write it."[9]

Sir Edward Poynter, R.A., whose *Festival* at the Academy had been severely handled by the critic, used the lecture in order to make a spirited defence of Michelangelo (and Poynter).

Dr Evans, more briefly, calls it "very unfair." So it is. Ruskin is never fair, but the essay deserves sympathetic criticism.

It must be borne in mind that, for the nineteenth century, there was a dreadful probability in Ruskin's analysis. It was not only he, but the great body of his contemporaries who saw in the work of Michelangelo the conclusion of Italian art. They were more critical of the Mannerists than we and far less indulgent to the

Baroque. It was reasonable to attribute the fall of art to him who had done so much to determine the character of its decline.

At the same time, there is, in Michelangelo's work, a disturbing element of sensuality, of sensuality directed into abnormal channels, a maltreatment of the feminine body, a profoundly suggestive reverence for masculine charms which Ruskin—in his situation—could neither recognise nor yet ignore. But, above all, Ruskin was surely right in his contention that Michelangelo was the painter and sculptor of death and it is not only in the terror and amazement of the *Last Judgment* but in the far more disquieting ecstasies of his dying slaves, the lovely body of Christ cast in a voluptuous *Liebestodt* upon the lap of a young Virgin or the majestic Adam poised between life and annihilation that he reaches his most splendid heights. Here indeed is "dark carnality" of a kind which, I suspect, was particularly intolerable to a man of Ruskin's uneasy temperament.

For the partisan of Ruskin the lecture on Michelangelo presents far fewer difficulties than do the lectures entitled *The Art of England*, delivered during Ruskin's second professorship in 1883, for here, in addition to admirable essays on nineteenth-century artists classified into mythic and classic schools and the schools of the hillside and the fireside, he adds a chapter on *Fairyland*. And when he enters those dubious glades and inglenooks we must refuse to follow him. Did the young men at Oxford feel something of our misgivings when they beheld him, the censor of Poussin, Rembrandt and Michelangelo, address himself, with only a few kindly and qualified reservations, to the sickly and beribboned moppets of Miss Kate Greenaway:

You have here, for consummate example, a dance
of fairies under a mushroom. . . . Here they are,
with a dance also of two girlies outside of a mush-
room; and I don't know whether the elfins or girls
are fairy footedest. . . the line is ineffably tender
and delicate. . . .[10]

What on earth did the young men make of this?
And what are we to make of it? It is easy, quizzing
Ruskin through psychiatric glasses, to smile at his
enthusiasm, to remember his fatal passions for
charming nymphets, and to dismiss the whole infatua-
tion for Miss Greenaway and her sister brush Miss
Alexander as the last, half conscious, senile pertur-
bations of thwarted sensuality. But listen to this,
this is Ruskin translating the words of another
writer:

From the honest but fierce laugh of the coarse
Saxon, William Hogarth, to the delicious smile of
Kate Greenaway, there has past a century and a
half. Is it the same people which applauds to-day
the sweet genius and tender malices of the one, and
which applauded the bitter genius and slaughterous
satire of the other? After all, that is possible,—the
hatred of vice is only another manifestation of the
love of innocence.
Thus far M. Chesneau—and [adds Ruskin] I venture
only to take up the admirable passage at a question
I did not translate: *"Ira-t-on au delà, fera-t-on
mieux encore?"* and to answer joyfully, Yes. . . .[11]

There had indeed been a softening of national
temper, and not only in England. Anatole France
(Ruskin incidentally, identified himself with that
author's Silvestre Bonnard) is making fun not only of

Ruskin, whom he calls "Sir James Tuckett," but, I think, of Chesneau in the following passage:

> The seraphic aesthete of Edinburgh has in an even more penetrating and lively fashion described the effect produced upon his mind by primitive painting. "The Madonna of Margaritone", says the revered MacSilly, "attains the transcendant aim of art, it fills the spectator with feelings of purity and innocence, they come unto it as little children. This is so much the case that I at the age of sixty-six, having contemplated this picture for three hours without intermission, felt myself become a tender nursling. While a cab took me through Trafalgar Square I shook my spectacles case like a rattle, laughing and gurgling. And when the servant at my boarding house brought me my dinner I, with the ingenuousness of first youth filled my ear hole with spoonfuls of soup."
>
> It is by results such as these, adds MacSilly, that we can realise the excellence of a work of art.[12]

The enthusiasm for perambulators was perhaps general: Du Maurier's aesthetes go into ecstasies over Mary and her little lamb, Max Beerbohm views society through a cloud of pinafores, May Belfort complains to an enraptured audience that Daddy wouldn't give her a bow-wow and, while Ruskin pointed to the strength of children's designs, Gauguin and Emile Bernard expressed their ambition to paint as a child paints.

If Ruskin sometimes "thanked God for little girls" over-enthusiastically he was not alone. Indeed he was doing something much more serious and interesting, he was rejecting the arguments which, since the time of Vasari, had been accepted as proof of the superiority of the High Renaissance.

He looked now with new eyes at the work of Cimabue; it was childish by the standards of the sixteenth century, nevertheless he was

A man of personal genius, equal to Tintoret . . . the intellect of Phidias with the soul of St. John, and the knowledge of a boy of ten years old, in perspective, light and shade etc.

He can't by any effort make his Madonna look as if she were sitting in her throne. She is merely standing stumpily. But I am prepared to assert her the sublimest Mater Dolorosa ever painted, as far as my knowledge extends, in the Italian Schools.[13]

This transition was in truth the by-product of a much larger development of his thought. He condemned not only Michelangelo but the High Renaissance. His Oxford lectures are increasingly devoted to the *Quattrocentisti*: Botticelli, Benozzo Gozzoli, Perugino and above all Carpaccio. He no longer rejected "purist art." Giotto was just as "strong" as Titian and differed from him only in that he had a different purpose, a purpose that was perhaps nobler and was certainly realised. "We ought," he says, "to measure the value of art less by its executive than by its moral power."[14]

This is a view which our own century has clothed in other language and accepted. It is an essential prerequisite to an understanding of art based upon something other than techniques and unhampered by the assumption that the translation of reality achieved in the sixteenth and seventeenth centuries provides a standard by which all art is to be judged. Here at last Ruskin was looking forward to the twentieth century.

By a malicious stroke of fate, at the very moment when Ruskin was laying the foundations of modern

critical method he turned to attack that artist who, in England, was regarded as the herald of a new epoch in painting.

> For Mr. Whistler's own sake, no less than for the protection of the purchaser, Sir Coutts Lindsay ought not to have admitted works into the gallery in which the ill-educated conceit of the artist so nearly approached the aspect of wilful imposture. I have seen, and heard, much of Cockney impudence before now; but never expected to hear a coxcomb ask two hundred guineas for flinging a pot of paint in the public's face.[15]

This is the only really familiar quotation from Ruskin: it has done him great harm. The sequel is equally well known. Whistler brought an action—to the secret joy, I suspect, of many artists who would have liked to have done likewise—Ruskin was too unwell to be in court, Whistler scored heavily off the Attorney General and, although he won only a farthing damages, gained an enormous moral victory.

Nothing in his life did Ruskin more injury than this lawsuit; he might blackguard Michelangelo to his heart's content and within ten years the matter would be forgotten, but to attack Whistler was an altogether more serious offence; Whistler's sallies have been remembered and always will be so long as men have a taste for the rapier play of wit, and they are remembered *against* Ruskin. To a whole generation of British artists Whistler was the leader on this side of the Channel of what was thought to be Impressionism, he was "modern art." By the twentieth century, all that the general public knew or wanted to know about Ruskin was that he "failed to understand Whistler, and, as spoilt elderly ladies and gentlemen

are liable to do, expressed his failure with violence and rudeness." It was Sickert, Whistler's disciple, who wrote these words and in justice to him I should add his own comment: "A great critic does not stand or fall by immunity from error."[16]

It is on the face of it strange that Ruskin, who defended Turner on charges very similar to those which he now made against Whistler, should have so far forgotten his own earlier teachings. But, despite his reference to the "pot of paint" I do not think Ruskin was concerned with technique but with intention. Whistler might say in court that he asked 200 guineas not for half-an-hour's work but for the experience of a lifetime, but in saying this he was not really at variance with *Modern Painters*, where Ruskin declares that three stokes of the pen of Raphael are a greater and better picture than the most finished work that ever Carlo Dolci polished into inanity. The trouble about *Cremorne Gardens* and the *Nocturne* from Ruskin's point of view was that they had no "moral intention," they offered nothing save an impartial comment upon aspects of the visible world; they were as detached, as amoral, as Constable. They caught Ruskin when he was on edge, angry and at a moment when he had reached a destination similar to that which Maurice Denis was to arrive at by a very different road, that is to say, a haven of religious and aesthetic certainty. Ruskin's discovery that Giotto was after all as strong as Titian was accompanied by a revival of his religious faith. He returned, not to any specific creed, but to Christianity in general, a kind of intense, vehement, anti-rationalist creed which E.T. Cook called "mystical agnosticism," a creed not unlike that which Tolstoy sought in his later years.

There was indeed a moment when it seemed that he might accept the tutelage of Rome. His reconversion in 1874 was effected at Assisi. It was associated in his mind not only with Giotto but with St Francis. The gentle piety of the saint, his rejection of the profit motive, his tenderness towards the brute creation, all appealed deeply to Ruskin. And St Francis made visible in painting, St Francis fortified by the grave authority of Giotto's pencil, the matchless serenity of his design, proved that the "big battalions" were, after all, on the side of God. There was a time when Ruskin toyed with the idea of becoming a Franciscan, it was rumoured that he had been received into the Church; but the idea faded, the rumours proved false: his was now too angular a personality to be fitted into the pattern of any organised faith.

During the years between 1870 and 1887 Ruskin's main work as an art critic was devoted to his Oxford lectures, although he collected and published several volumes which are in a sense guide books or school histories: *The Bible of Amiens* (1880–5) in which he discusses northern Gothic, *Mornings in Florence* (1875–7) which reflects his revived interest in Giotto and *St. Mark's Rest* (1877–84), an unfinished essay on his old love, Venice. He also published a new drawing book, *Laws of Fesole* (1878), which is far inferior to *Elements of Drawing*. His collection of essays on geology (*Deucalion*), another on botany (*Proserpina*) and a third on ornithology (*Love's Meinie*) represent the work of several years both in and out of Oxford. Ruskin brings to these scientific works the same exasperating mixture of charm, arrogance and inconsequence that one finds in his art criticism. *Deucalion* is the most readable, partly because Ruskin knows more about geology than he

does about flowers and birds, and partly because, right or wrong, he can put up a lively and convincing case for his hero, Forbes, and is most entertainingly rude about his opponent, Tyndall. *Deucalion* also contains some admirable drawings and some memorable prose:

> many formations are best to be conceived as glaciers, or frozen fields of crag, whose depth is to be measured in miles instead of fathoms, whose crevasses are filled with solvent flame, with vapour, with gelatinous flint, or with crystallising elements of mingled natures: the whole mass changing its dimensions and flowing into new channels, though by gradations which cannot be measured and in periods of time of which human life forms no appreciable unit.[17]

Ruskin's almost Miltonic power of language is given more scope here than in botany and ornithology where his attempts to rename and reclassify darken council, and his efforts to refute Darwin can have satisfied only those who were already determined that he must be refuted.

Apart from these excursions—and they were not brief excursions—Ruskin was still very intent upon the social questions that had engaged him ever since 1860. In 1870, finding the ugliness, cruelty, baseness and apathy of England quite intolerable he decided to address the working men of England in a series of letters entitled *Fors Clavigera*. In the entire history of political agitation there can have been no stranger publication than these letters which appeared at irregular intervals for fourteen years. The very title is enigmatic and Ruskin, who had a passion for hazardous derivations, hardly enlightens us when he attempts to

explain this fate, force or fortune with a nail. It was not advertised and was sold in such a way that it had the least possible chance of being widely disseminated. The style shows Ruskin at his most elliptical and allusive and it is insanely discursive.

Ruskin was never able to stick to the point and could seldom finish that which he had begun. The second volume of *Modern Painters* is a divagation from the first and *The Seven Lamps of Architecture* is an escape from the second. His ability to write about anything save the matter in hand shows itself very much in the third, fourth and fifth volumes. In his Oxford lectures he flies inconsequently from theme to theme.

In *Fors Clavigera* Ruskin abandons all attempts at coherent method. He writes whatever comes into his head, gives us the stream of his consciousness, and mingles straight socialist propaganda with art criticism, chapters of Marmontel, arguments about glaciers, a recipe for Yorkshire goose pie, prose poems addressed to St Ursula, animadversions against the South Kensington system of art teaching and fragments from an unfinished biography of Sir Walter Scott. "In later years," says Sir Leslie Stephen—and one can almost hear that literal-minded author's impatient groan—"his incapacity for consecutive writing becomes bewildering."[18]

This is a just and serious criticism of what is in truth a grievous fault. The tortuous divagations which are pardonable, delightful even, in *Tristram Shandy* or *Don Juan* become exasperating in an author who, unlike Sterne or Byron, has an urgent message. Ruskin is, in effect, telling us that our house in on fire; he knows where the fire extinguisher is hidden and he will lead us to it. Why, then, does he pause to

look at a flower, turn from his path in pursuit of butterflies, wander away into the shrubbery or saunter back to enjoy a more extensive view of the conflagration? We suspect, and this is ruinous to his purpose, that he is not quite so much in earnest as he had made us believe. But perhaps the truth lies elsewhere: in later years and particularly in *Fors Clavigera*, there were, probably, many topics which he could neither pursue nor abandon, things which lay always in the recesses of his mind but to which he dared not approach too closely. He writes, sometimes, like a man who suddenly sees the words "no entry" before him and must swerve to left or right if he is to remain within the law.

Whatever the motive for his divagations may have been, the effect is to make *Fors Clavigera* ludicrous as propaganda. And yet when he sets himself to it, Ruskin can write with the wisdom of a Solon or the fury of an avenging angel. His passages on the suppression of the Commune, on capitalist exploitation, on usury and on war are splendid in their passionate indignation; his thoughts on education are wise and temperate.

Fors Clavigera was used to launch Ruskin's own political organisation and it became, more or less, an organ of that body. I call the "Guild of St George" a political organisation for want of a better term but if, as Talleyrand said, "politics is the art of the possible" then the Guild was certainly unpolitical. The immediate aim seemed modest enough, land was to be reclaimed, workers to be resettled. The ultimate aims were vast; a new rural society was to be created, firstly in England and then throughout the world. A new peasantry, strictly disciplined and sternly educated would be established on the land

under a resident gentry. Machinery would be abolished, prices fixed, newspapers suppressed, literature regulated. There would be schools, museums, libraries and home industries. Typically, Ruskin gave as much attention to the adornments of life as to its economic arrangements. There would be a currency and a costume of his own invention, a new scientific nomenclature, a new geographical terminology.

Ruskin himself called it his "Island of Barataria." It was, almost entirely, a plaything of his mind, a dream world of contented peasants and virtuous administrators, a world without want or liberty. The reality was, necessarily, different:

> Some cottages in Wales, twenty acres of partly cleared woodland in Worcestershire; a few bleak acres in Yorkshire; and a single museum.[19]

Ruskin contributed a tenth of his capital to the scheme but his friends could not be induced to do likewise. William Morris and Carlyle were both, in their different ways, sceptical. The only support came from a few working men who would have been glad to have gone back to the land but had no tithes to offer.

In 1875 Rose La Touche died, eliciting a cry of despair in the pages of *Fors Clavigera*. Thereafter it seemed to Ruskin that the heavens were actually, literally, darkening. In his distress he turned to supernatural guides, the spirit of Rose rapped upon the table of Mrs Cowper Temple, the spirit of St Ursula appeared in dreams and directed the editorial policy of *Fors Clavigera,* he cast horoscopes, he sought help in random openings of the Bible. Suddenly he had become an old man, he was afflicted by "grotesque, terrific, inevitable dreams" from which

114

he awoke to find that for days he had been mad. The attacks of lunacy recurred, they became ever more frequent, he brought *Fors Clavigera* to an end and resigned his professorship.

And then, just as he seemed to be sinking into unbroken delirium he made a brief recovery. He returned to Oxford. One more love affair awaited him and one last great book.

REFERENCES

1. Wilenski, *John Ruskin* (1933), p. 193.
2. *Introduction to Vol.* XX, xliv.
3. J. H. Whitehouse (ed.), *To the Memory of John Ruskin* (1934), p. 33.
4. *The Relation between Michael Angelo and Tintoret* XXII. 83.
5. *Ibid.,* XXII. 84.
6. *Ibid.,* XXII. 97.
7. *Ibid.,* XXII. 101.
8. *Ibid.,* XXII. 102.
9. *Memorials of Edward Burne Jones,* II, pp. 18–19.
10. *The Art of England,* XXXIII. 343–4.
11. *The Art of England,* XXXIII. 343.
12. Anatole France, *L'Ile des Pingouins* (1908), Bk. III. Ch. V.
13. Letter to Charles Eliot Norton, 21 June. 1874, XXXVII. 114.
14. "Giotto and his works in Padua," XXIV. 28.
15. *F.C.,* [letter 79] XXIX. 160.
16. Sickert, *A Free House!* (ed. Osbert Sitwell, 1947), p. 45.
17. *Deucalion,* XXVI. 5.
18. Leslie Stephen, *Studies of a Biographer* (1902), Vol. III. p. 90.
19. *Introduction Vol.* XXX, xxii.

Chapter 6

PRÆTERITA

In 1887 Ruskin fell in love with a young art student, Kate Olander. He picked her up—it is hard to find a more dignified phrase that will accurately describe the transaction—in the National Gallery, discovered that she, like every other nice, goodlooking girl he had ever met, had talent, and undertook her education. He wrote her enchanting letters, love letters which, nevertheless, she received in all simplicity and it was not until he asked her, in so many words, to be his wife that she understood the magnitude of her conquest. She referred him to her parents and they, who had already felt some misgivings about the relationship, forbade her to have anything more to do with Ruskin. He was, after all, nearly seventy, frequently insane and of dubious value as a husband.

That would not have been the end of the matter, for Miss Olander had felt enough of Ruskin's charm to be ready to carry on a secret correspondence, and if need be, to make a Platonic marriage with the great man. But by this time Ruskin was supervised by a formidable guardian, Mrs Severn, a widowed cousin who had attended Mrs Ruskin. She now gave the same devoted care to the son that she had bestowed on the mother. In 1872 he had retired to Brantwood near Coniston and there he was joined by his duenna who, as his health deteriorated, occupied a more and more commanding position. Mrs Severn may well have been moved by the same considerations as Mr and Mrs Olander; she may have reflected that Ruskin could hardly fail to make himself ridiculous and might

probably be made unhappy; at all events she inter-
cepted Kate Olander's letters and it was probably as
a result of her action that Ruskin's editors suppressed
all mention of this last flaming indiscretion.

But today, reading those last serious love letters,
the reader cannot repress a certain feeling of awe and
admiration for Ruskin. There was surely something
rather splendid about this final pathetic gallantry.
Ruskin, at sixty-eight, may have been an old fool, but
he was an old fool in the grand manner.

In fact there is something altogether heroic about
Ruskin's last years of intermittent sanity. With the
threat of total unending madness always at his side he
had to learn to avoid all those topics that would fling
him into an ungovernable passion. And yet what
subject was there which might not lead to disaster?
Art and politics, the corruption of nature and the
wickedness of man, they were all tied together in his
mind. And of what else could he write? And yet he
was too much of an artist to remain idle; already, in
Fors Clavigera he had sometimes taken refuge in his
own past, now he decided to embark upon a full
length autobiography. The result was *Præterita*.

It is fashionable in these days to praise this work,
and even those who find Ruskin most unsympathetic
admit its charm. I think that the common view is
right and that this is Ruskin's masterpiece, and
certainly it is his most perfectly written book.

Ruskin's style may be divided into three epochs.
First the elaborately decorated, richly poetic style
of his youth, a style which I have already tried to
defend, but which certainly requires defence. Then,
the simple and more direct style of his middle years
and finally the limpid and restrained English of
Præterita. Now to my mind Ruskin in his second

manner is ill-at-ease. He sacrifices the romantic exuberance of his youth without attaining a new style of corresponding strength; he has thrown his best weapon away and has not learnt to fight without it. But he *does* learn and at the very end when he must perforce be calm, when he is no longer trying to preach and his simpler method is matched to a simpler theme, he can write thus:

> The mode of journeying was as fixed as that of our home life. We went from forty to fifty miles a day, starting always early enough in the morning to arrive comfortably to four o'clock dinner. Generally, therefore, getting off at six o'clock, a stage or two were done before breakfast, with the dew on the grass, and first scent from the hawthorns; if in the course of the midday drive there were any gentleman's house to be seen,—or, better still, a lord's—or, best of all, a duke's,—my father baited the horses, and took my mother and me reverently through the state rooms; always speaking a little under our breath to the housekeeper, major domo, or other authority in charge; and gleaning worshipfully what fragmentary illustrations of the history and domestic ways of the family might fall from their lips.[1]

In preparing this essay I have read the works of a score of Ruskin's biographers and in almost every case the unfortunate writer is faced at the outset by the task of reproducing the substance of the opening chapters of *Præterita*. Some of these authors have great literary skill, nevertheless, there is not one of them that does not suffer from the comparisons that he invites.

In his preface Ruskin says that he wrote *Præterita*:

frankly, garrulously, and at ease; speaking of what
it gives me joy to remember at any length I like—
sometimes very carefully of what I think it may be
useful for others to know; and passing in total silence
things which I have no pleasure in reviewing. . . .²

He is always frank and certainly he is at ease, for
once he will not torment his readers—or himself;
for once in a way his stupendous literary engine could
be released from its dreadful labours and set to the
more grateful task of a pleasant jaunt. No doubt he is
also, as he says, garrulous, but the oppressive garrulity
of *Ethics of the Dust* or *The Cestus of Aglaia* is not
felt, for here he is not preaching but conversing. He
meanders but he is far less discursive in these pages
than in his earlier works. He proceeds at a leisurely
but reasonable pace through infancy and early child-
hood, takes the reader, as we have seen, on the
family's sherry-selling excursions and then to the
greater adventure of foreign travel.

We must have still spent some time in town-
seeing, for it was drawing towards sunset when we
got up to some sort of garden promenade—west of
the town, I believe; and high above the Rhine, so
as to command the open country across it to the
south and west. At which open country of low
undulation, far into blue,—gazing as at one of our
own distances from Malvern of Worcestershire, or
Dorking of Kent,—suddenly—behold—beyond!
There was no thought in any of us for a moment
of their being clouds. They were clear as crystal,
sharp on the pure horizon sky, and already tinged
with rose by the sinking sun. Infinitely beyond all
that we had ever thought or dreamed,—the seen
walls of lost Eden could not have been more

beautiful to us; not more awful, round heaven, the walls of sacred Death.[3]

Notice how Ruskin prepares us for this first view of the Alps—his judicious use of "town-seeing" with its suggestion of a humdrum inspection of dull streets, his interposition of Malvern and Dorking recalling blue distances but at the same time something quiet and domestic in comparison with that which is to come; and then by that very doubt, no sooner formed than dismissed, as to whether the mountains might not be clouds, a doubt further annulled by his description of their sharp clarity, his imposition of that moment of shock, of joyful, indisputable recognition that comes when we actually see that which we have known only in words or pictures. Nor does he coarsen the effect, as he did in a boyhood poem, by exclaiming: "the Alps, the Alps!" Notice finally the use of the first person plural. In the next paragraph he speaks only about himself and reflects upon that "blessed entrance into life for a child of a temperament such as mine" and considers the effect of Rousseau upon the sensibility of the nineteenth century, thence, by a natural transition, to a passage of pure introspection:

I went down that evening from the garden-terrace of Schaffhausen with my destiny fixed in all of it that was to be sacred and useful. To that terrace, and the shore of the Lake of Geneva, my heart and faith return to this day, in every impulse that is yet nobly alive in them, and every thought that has in it help or peace.[4]

The change of person is made with so little emphasis that we feel rather than perceive it: but it is

important. The instant of delighted recognition comes not simply to him but to his whole family, in that moment of delight he is at one with them and in letting us know this we learn something important both about him and about them.

Thackeray's daughter said of Ruskin that he should have been a novelist; he, as he himself remarked, possessed no powers of invention: but certainly, in *Praeterita* he has an astonishing ability to bring places and people to life. We come to know his parents very well, so well that we know how they will behave in any circumstances, Mr Ruskin balancing parental affection against commercial prudence in the matter of Turner drawings and, of course, missing every trick as rich men commonly do when they dabble in art; Mrs Ruskin sitting straight-backed and leaving the carriage cushions untouched all the way from Herne Hill to Salerno. And when they take us by surprise, when Mr Ruskin reads *Don Juan* to Mrs Ruskin and to his little boy, when Mrs Ruskin giggles because Anne the nurse has shown her petticoats to the monks of St Bernard, when the family is permitted to applaud Grisi's voice and Taglioni's ankles, we are convinced, not simply because Ruskin is obviously telling the truth but because he has made his parents so credible and so familiar that we feel that we might have guessed at these amiable lapses from evangelical consistency.

There is here a solid and consistent reality which is absent from all his other work. His art criticism is peopled by moral phantoms. He can make us see nature or a picture: but he cannot make us see the artist, although he tries hard to do so, because the artist is a creature of his own imagination—Géricault is a hard-hearted rogue, Filippo Lippi a virtuous

protestant, Caravaggio a blackguard and so on. His lovely and lucid passages of descriptive writing and his powerful argumentation are haunted and obscured by these entirely unconvincing personages. In the same way, in his political writings, a romantic belief in the past felicity and future perfectibility of man obscures much that is penetrating, pertinent and wise. In all his writings, save only *Præterita*, we are bothered and involved in ethical vapours which allow us only a partial and imperfect glimpse of reality. But here the weather is fair and we can enjoy the view from beginning to end.

> ... extremely lovely at fifteen, Adèle was not prettier than French girls in general at eighteen; she was firm and fiery, and high principled; but, as the light traits already noticed of her enough show, not in the least amiable; and although she would have married me, had her father wished it, was always glad to have me out of her way.[5]

They were indeed "light traits." We seem to know Ruskin's first love intimately but what has he told us about her? Individually, almost nothing, collectively that she and her sisters were the first well-bred and well-dressed girls he had ever seen.

> I mean of course, by well-dressed, perfectly simply dressed, with Parisian cutting and fitting. They were all "bigoted"—as Protestants would say; quietly firm, as they ought to say—Roman Catholics; spoke Spanish and French with perfect grace, and English with broken precision: were all fairly sensible, Clotilde [Adèle] sternly and accurately so. . . .[6]

What else? She was "a graceful, oval-faced blonde"

at fifteen and she laughed at his literary efforts and that is really all. Ruskin gives us no remembered intonation, no particularity of gesture, no shred of tarlatan or blonde coil-encasing locket and yet she lives as Mrs Norris and Miss Bates live—I will not say Elizabeth Bennet and Emma Woodhouse, for these exist more intensely than could any creature veiled in the incomprehensibility of flesh and blood—but, yes, Adèle is as real as Miss Bates and Ruskin makes her so with nothing better to work with than the fact that her face was oval, her hair blonde, her person tolerable and well-dressed, her character resolute and unsentimental. Unable to follow her out of the drawing-room, unable ever to take the liberties of a lover or a novelist and make his way into the privacies of her solitude and her bosom, he shows us Adèle by inference, exhibiting that which he *does* know, that is to say, his own adolescent heart, and—with a fine wry humour—his adolescent absurdity.

> while in company I sate jealously miserable like a stock fish (in truth, I imagine, looking like nothing so much as a skate in an aquarium trying to get up the glass). . . .[7]

In a later chapter Ruskin describes the object of his greatest passion—Rose La Touche—and here he is very much more explicit and does in fact draw a very lovely picture of Rose at the age of nine. And yet, for all its charm, this description is less telling than the slight but eloquent indications from which we may deduce the character of Adèle.

It is hard to know how to continue this description of *Præterita*. One needs to quote the whole book and it is my aim to keep this chapter brief. A word should,

however, be said regarding the omissions, which are important.

If Ruskin could have given us an account of Effie similar to that which he gives of Rose and of Adèle how grateful we should be. But she is never mentioned, and in fact it is implicit in the psychological contract of the work that she should make no appearance. *Præterita* was to be written "frankly" and "at ease." To be frank about Lady Millais and yet to be at ease in discussing her was, clearly, impossible. She was one of those dangerous subjects that he dared not touch and although Ruskin is frank—almost to excess—in his manner of publicly unbuttoning his heart, telling his contemporaries everything that they might care to know about his courtship of Rose, his despair and his madness, never, after her escape, does he mention Effie in public and only when driven to it in private. Least of all could he afford to do so now, when the least excitement could throw him into a paroxysm from which he might never emerge. Neither could he venture upon the agitating question of social reform, the black wickedness of a world which refused to listen to his admonitions. Kenneth Clark has pointed out that even the city of Venice, for which he had once felt so much, had suffered too much of wreck and ruin, had become too painful, for prolonged contemplation.

For all his care, his spells of madness returned, and returned ever more frequently. By the summer of 1889 it became clear that he would never finish *Praeterita*; he hastened to add a chapter of tribute and gratitude to Mrs Severn, but he found it increasingly hard to write. By 1890 the great outpouring of magnificent prose was ended. This was how he finished, he is writing of Charles Eliot Norton and the

Fonte Branda, the celebrated fountain of Siena:

We drank of it together, and walked together
that evening on the hills above, where the fireflies
among the scented thickets shone fitfully in the
still undarkened air. *How* they shone! moving like
fine-broken starlight through the purple leaves.
How they shone! through the sunset that failed
into thunderous night as I entered Siena three days
before, the white edges of the mountainous clouds
still lighted from the west, and the openly golden
sky calm behind the gate of Siena's heart, with its
still golden words, *"Cor magis tibi Sena pandit,"*
and the fireflies everywhere in sky and cloud rising
and falling, mixed with the lightning, and more
intense than the stars.[8]

Thus he ends, wandering a little, as usual, but here
it certainly does not matter, for in this vein we can
accept him on any terms, regretting only that he can
give us no more.

REFERENCES

1. *P.*, XXXV. 32–33.
2. *P.*, XXXV. 11.
3. *P.*, XXXV. 115.
4. *P.*, XXXV. 116.
5. *P.*, XXXV. 229.
6. *P.*, XXXV. 178.
7. *P.*, XXXV. 180.
8. *P.*, XXXV. 562.

Chapter 7

PRIVATE LIFE

Ruskin died in 1900. He had been permanently and incurably mad for ten years and was, for all practical and public purposes, already buried. The work of the biographers began before his actual death and to this period we owe such early books as Collingwood's *Life and Work of John Ruskin*, the studies of Professor Waldstein and Mr Spielman, the examination of his style by Mrs Meynell which is, in itself, a very stylish production, and Lady Ritchie's charming sketch. Meanwhile Wedderburn and Cook had embarked upon their admirable and indispensable edition of the works.

As biography—and it is with the biographies that I am now concerned—these early studies had the advantages and disadvantages of propinquity. Good taste, the feelings of Mrs Severn, the La Touche and the Millais families, kept the biographers quiet. The life of Ruskin is, however, too fascinating a study not to attract attention and in 1910 A. C. Benson in *Ruskin—the Study of a Personality* drew a lively and, on the whole, a sympathetic portrait; he sees in the life story of Ruskin an example of arrogance punished by the Almighty through the agency of Rose La Touche (which seems a little hard on Rose). The book is interesting rather than acute. Sir E. T. Cook's admirable *Life* followed in 1911. Thereafter there was a lull and in England no important work was written until the late nineteen-twenties when Ruskin's character began to be scrutinised with greater freedom. There was then a spate of biographies of which

by far the most important was Mr Wilenski's *John Ruskin: An Introduction to the further Study of his Life and Works* (1933). Himself an important art critic and standing at a sufficient distance from his subject to be fair and dispassionate, Wilenski examines Ruskin's work and also his psyche with a new, frank, and perceptive freedom.

Since 1945 a number of scholars have become interested in Ruskin's personality, notably Kenneth Clark and Dr Joan Evans. *Ruskin the Great Victorian*, a long biography making considerable use of unpublished material, was written by Mr Derrick Leon and posthumously published in 1949. It was an unlucky book for it might have been in a sense the standard work on Ruskin; it is certainly the longest, best documented, most thoughtful and most enthusiastic of lives, but unfortunately its author died before it was completed; some of the writing has been left uncorrected, and some of the reasoning will hardly bear examination. Mr Leon defends Ruskin in every transaction of his life, his marriage, his quarrels, his speculations, and presents a hero who in the end is almost tiresomely heroic. At the same time he represents Ruskin's aesthetic and political ideas in such terms that he seems rather to be translating Ruskin's thought into language that will be acceptable to his own generation than offering it with all its idiosyncracies, asperities and necessary limitations. But the chief disaster which befell this work was the publication of Admiral James' *The Order of Release* (1947) and shortly afterwards of Mr Quennell's extremely perceptive *Ruskin, the Portrait of a Prophet* (1949). Both these authors made use of hitherto unknown material which shows us the story of Ruskin's marriage from Effie's point of view. Mr

Quennell is an impartial and fair-minded commentator;
Admiral James, on the other hand, is the gallant,
impetuous and sometimes careless champion of his
grandmother. There can be little doubt that *The
Order of Release* did Mr Leon's book and Ruskin's
reputation considerable damage. It led to a rejoinder
by Mr Whitehouse, the *Vindication of John Ruskin*
(1950) and a further contribution to the study of
Ruskin's personality appeared in 1953 with the
publication of Ruskin's letters to Kate Olander. Upon
the basis of this new evidence Kenneth Clark, Dr Joan
Evans and Mr John D. Rosenberg have constructed
more balanced estimates in studies which are to be
recommended on biographical as on other grounds.

Ruskin's private life has in fact been made so very
public and is so closely connected with the nature of
his genius that we cannot ignore it. It is necessary,
for the point is still disputed, to ask in the first place
why his marriage was never consummated. He himself
gave two different explanations; to his friend Greville
Macdonald he said that he had never loved Effie, to
Kate Olander that it was *she* who did not love him.
The publication of his love letters—odd, highly
literary productions, makes it clear, either that he was
truly in love, or that he thought he was. Both Mr and
Mrs John Ruskin have given us their accounts of their
life together; and according to him they "agreed" that
they would not consummate the marriage, according to
her he simply informed her that he did not intend to
"marry" her. Ruskin attributes this abstinence to his
wife's ill-health, its continuance until at length they
were on terms which forbade love, to a desire to post-
pone children and to travel abroad freely. Effie's
account, written in 1854, is not altogether different
but makes one very significant addition:

He alleged various reasons, hatred to children, religious motives, a desire to preserve my beauty, and finally this last year told me his true reason (and this to me is as villainous as all the rest) that he had imagined women were quite different from what he saw I was, and that the reason he did not make me his Wife was because he was disgusted with my person the first evening 10th April.[1]

Even in this final article the two accounts are not utterly different; in his statement to his proctor in the nullity suit Ruskin says:

Though her face was beautiful, her person was not formed to excite passion. On the contrary there were certain circumstances in her person which completely checked it.[2]

Who can doubt reading this evidence that passion was indeed "checked" or that Effie was right in saying to Mrs La Touche that "from his peculiar nature he is quite incapable of making a woman happy"? Before marriage, Ruskin wrote the passionate letters of an aspiring lover, after marriage he wrote with the intimacy of a contented husband:

I look forward to meeting you; and to your *next* bridal night; and to the time when I shall again draw your dress from your snowy shoulders: and lean my cheek upon them, as if you were still my betrothed only; and I had never held you in my arms.[3]

or again:

I forget myself—and my wife both; if I did not I could not stop so long away from her: for I begin to wonder whether I am married at all, and to

think of all my happy hours, and soft slumber in my dearest lady's arms, as a dream.[4]

There is here a kind of playing at physical passion, a game of desire and consummation which could be undertaken at a distance but not at close quarters.

What then are we to make of Ruskin's flat statement that his excuses were perfectly genuine, that he did in fact offer to consummate the marriage and that he was not impotent?

I think that Ruskin was never consciously dishonest. He says:

> She sometimes expressed doubts of its being *right* to live as we were living; but always continuing to express her wish to live so. I gravely charged her to tell me if she thought she would be happier in consummating marriage or healthier, I being willing at any time to consummate it; but I answered to her doubts as to its being *right*, that many of the best characters in church history had preserved their virginity in marriage.[5]

Here again Effie's version is not far from Ruskin's:

> After I began to see things better, I argued with him and took the Bible but he soon silenced me....[6]

If these exchanges did not conceal a fearful tragedy it would be hard not to smile at the spectacle of Mr and Mrs Ruskin thus earnestly discussing the propriety of bedding together. But it is not difficult to imagine the nature of the argument, to see how a young girl reared at that high tide of Victorian prudery would base her claims to the natural delights of marriage upon theological rather than sensual grounds; and it is easy to see how Ruskin could convince her

and himself that she was in the wrong.

It may appear less understandable that Ruskin should say:

> I can prove my virility at once, but do not wish to receive back into my home the woman who has made such a charge against me.[7]

Ruskin could no doubt have proved his virility to his own satisfaction but not to Effie's. He was, after all, nearly as innocent as she and may well have imagined that, not being organically impotent (we know that from childhood he had been addicted to auto-erotic practices) he would not be impotent with his wife. Indeed the tragedy was precisely that he did not realise this.

I have discussed Ruskin's sexual incompetence with what may, to some readers, seem excessive care because without an understanding thereof we cannot assess the really serious charges that have been brought against him by Admiral James. No one will be so foolish as to blame him for being impotent, but he may more justly be accused of making his wife unnecessarily unhappy. Old Mr and Mrs Ruskin were not kind to her, John did nothing to make them more so; he wrote harshly of her to his father and treated the whole business with a cold *insouciance* that disgusted Millais. Effie was cold-shouldered, scolded, excluded, thrust into compromising positions. She was, I suspect, a rather hard young woman, but she certainly needed all her hardness in six years of married life with Ruskin.

If Ruskin had been perfectly normal his conduct would have been unforgivable, but he was far from normal and we may at least attempt to understand it. He was, as I see it, guided by two unconscious

motives: a fear of consummating the marriage and a fear of knowing why he did not want to do so. To this end he invented the excuses that I have mentioned, excuses that cannot have been perfectly convincing even to himself. In the end he was driven to a different line of argument, he would not have her because he did not want her and did not love her. If only he could come to hate her then he would no longer be tormented by this terrifying union of desire and disgust. In the end, not without much help from jealous parents and perhaps a little from Effie herself, he did indeed hate her and, when she left him, he was sincerely glad.

Mr Gladstone delivered what I believe to be a perfectly sound judgment on the whole affair when he said, "should you ever hear anyone blame Millais, or his wife, or Mr. Ruskin, remember there was no fault: there was misfortune, even tragedy; all three were perfectly blameless."[8]

Nevertheless, somewhere in Ruskin's nature there was, I think, an element of cruelty, a vein of thought and feeling completely at variance with the predominant form of his personality but which had a profound effect upon his work as a critic and a social thinker.

If we return to Ruskin's infancy, to that "poor little Cockney wretch, playing in a dark London nursery, with a bunch of keys,"[9] it will be found that even for a boy in whom there was no congenital disposition to madness—and in Ruskin's case there almost certainly was—the circumstances of his upbringing would have turned his mind to the strangest confusions of affection.

Mrs Ruskin dedicated her only son to God, but the God to whom she gave him was her own particular

evangelical deity whose Book was most perfectly expounded at Herne Hill. Religion, for that deeply religious child, was not a communal thing, it belonged to Mama. In *Præterita* he describes his intense horror of Sunday, a day which cast its preceeding gloom not only on Saturday but on Friday too, so much was it hated.[10] He hints also at his dislike for his mother, the mother from whom he tried in vain to detach himself. This dialectic of love and hate, which is perhaps not uncommon, was made terrible and inescapable for a child who, partly by policy and partly by accident, was cut off from every other important relationship. Papa and Mama were everything, they ruled and in fact they *were* his world, inevitable, adorable, intolerable and inescapable; no equal partnership, no rough and tumble give and take and common intercourse with brothers, sisters and schoolfellows was permitted. He was trained from infancy to regard the world as a place in which he was protected and restrained, where kindness and cruelty were calmly and invariably handed down from above, in which he must always be ruled by a united triumvirate consisting of his mother, his father and his God.

Profoundly religious, he continued to regard the universe as a monarchy in which the relation of God to man, of man to man and of man to woman must be that of the parent to the child.

In his political thinking Ruskin is in the best and worst sense of the word paternalist. The monarch must care for his people and, if need be, punish them with hideous severity:

His [Froude's] reverence for the righteousness of old English law holds staunch, even to the recognition of it in the most violent states of—literal—

ebullition: such, for instance, as the effective check given to the arts of Italian poisoning into England, by putting the first English cook who practised them into a pot of convenient size together with the requisite quantity of water, and publicly boiling him,—a most concise and practical method.[11]

Froude, who apprehends the horror of this judicial barbarity and feels the need to offer the reader some word of apology, does not escape the indignant censure of Lytton Strachey, but what are we to say of Ruskin's light-hearted commentary save that it shows a lack of imagination—or a superfluity of something else?

There are, in fact, moments when Ruskin fills us with horror. He told the Oxford undergraduates:

We are still undegenerate in race, a race mingled of the best northern blood. We are not yet dissolute in temper, but still have the firmness to govern and the grace to obey. We have been taught a religion of pure mercy, which we must either betray, or learn to defend by fulfilling.

England was to fulfil the religion of pure mercy by:

seizing every piece of fruitful waste ground she can set her foot on, and there teacing these her colonists that their chief virtue is to be fidelity to their country, and that their first aim is to be to advance the power of England by land and sea. . . .every man of them must be under the authority of captains and officers.[12]

In this century we have seen whither such preaching may lead and may therefore be unduly hard on Ruskin, who could scarcely have imagined what the doctrines of racial purity and imperial destiny might

come to mean in practice. Nevertheless it is impossible not to discern in them an authoritarian temper which saw in the *fasces* of the lictor not only a symbol of authority but an instrument of punishment. In Ruskin this fierce temper mingles with a real tenderness of heart and a genuine indignation at the spectacle of social cruelty.

It is the same with his art criticism: the function of a critic is in his view not only to extol that which is good, but to punish that which is bad. For him there is no middle way: if Turner is to be praised then Claude must be punished, the exaltation of Tintoretto involves the abasement of Michelangelo. And again, in his art teaching, no teacher was ever kinder or more delightful, more ready to see promise or to assist nascent talent, and none was sterner in his injunctions, harsher or more cruel in repressing insubordination or insincerity.

In personal relations he would command and might sometimes obey, but he could seldom live on equal terms with anyone. He loved to help, to guide, to protect a young or unfortunate painter, and was infinitely thoughtful and kind to humble artists like William Hunt, or to his pupils at the Working Men's College. With extreme delicacy he managed to assist the young Rossetti and his "children" Mr and Mrs Burne Jones. But when these artists could stand on their own feet and dispute his opinions, Ruskin could do nothing for them.

On the other hand, when he encountered superior merit he bowed low before it. It comes as a shock to find Ruskin at the age of fity-three addressing Thomas Carlyle as "my dearest Papa." He used much the same form for Mr F. S. Ellis ("My dear Papa Ellis") and in the same way Charles Eliot Norton was "my second friend and my first real tutor."

This being the case with his masculine relationships
it is not surprising that women were also conceived of
in a paternalist relationship. He might say, and truly
I think:

I never disobeyed my mother . . . I have honoured
all women with solemn worship.[13]

But when he plans to marry a young girl he writes
to her in another fashion. Towards Effie he assumes
the character of a schoolmaster; to Kate Olander he
writes thus:

I was lying awake last night and planning what
you can wear round your neck—it is to be the finest
and purest chain of Venice—no gold is so pure—and
they make the links so small it looks like the white
lady of Avanel's girdle—but I'm going to have it
seven times round: rather tight for a *necklace* to
show what a perfectly chained and submissive child
you are; so mind you send me the measure care-
fully—just above the shoulders.[14]

This is gentle, flirtatious severity. But what are we
to say of his criticism of Millais' *Spring*, written in
1859 just after he had met Rose La Touche? He
complains of the ugliness of Millais' subjects:

And in this present picture, the unsightliness of
some of the faces, and the preternatural grimness
of others, with the fierce colour and angular masses
of the flowers above, force upon me a strange
impression, which I cannot shake off—that this is
an illustration of the song of some modern Dante,
who, at the first entrance of an Inferno for English
society, had found, carpeted with ghostly grass, a
field of penance for young ladies, where girl-
blossoms, who had been vainly gay, or treacherously

136

amiable, were condemned to recline in reprobation, under red-hot apple blossom, and sip scalding milk out of a poisoned porringer.[15]

Ruskin's passions were, as Mr Quennell puts it, "nympholeptic." The conjured image of the beloved imposed itself upon reality. He saw girls as he wished to see them until reality forced itself with brutal strength upon him and he discovered that "he had imagined women were quite different." The figure that he visualised was a child and it was as a child that he first saw Adèle, and Effie, and Rose, it was only as children that women could play their part in his filial-paternal scheme of things.

But if this area of Ruskin's personality is comparatively easy to understand there are others which remain unexplored. I should like to suggest, but no more than suggest, the directions in which we should look.

Mr Wilenski has pointed out that Ruskin suffered from that form of recurrent depression and corresponding elation that has been called *folie circulaire*. This had an effect upon his work—he would start new books in his phases of euphoria and abandon them in fits of depression and, in the same way, his periods of religious doubt would be followed by blessed moments of religious certainty. Here, however, we merely touch upon the symptoms of his malady. What was the malady itself, what was the nature of the demon that returned from within his mind?

It was undoubtedly, a black devil. Devils are usually black and, in the West at all events, it is usual enough to associate blackness with sin and death: but in Ruskin's work this imagery has a special and obsessive force. Few critics would follow Ruskin in

declaring that the habitual use of dark backgrounds has never been coexistent with pure or high feeling, that Rembrandt, "a strong sullen animal in its defiled den," is "distinguished only by the liveliness of his darkness"; that all "vile things are dark and noble ones fair"; that the "Ruffian Caravaggio" is to be condemned for his "pictures full of horror, their colour for the most part gloomy grey." The theme runs all through his critical work and accounts in some measure for the apparently capricious nature of his preferences. For him the word "dark" means "bad." It was a symptom of his approaching madness when after a series of inclement summers he began to fancy that nature herself was darkening and that the skies were veiled with smoke. The incautious condemnation of Whistler was itself provoked by a picture of night.

What then did he fear in the dark? Undoubtedly he was afraid of death and he had a particular aversion for all kinds of funeral apparatus. But he also had a fear of other horrors that came to him out of the blackness of night.

In 1869 he makes the following record in his diary:

Got restless—taste in mouth—and had the most horrible serpent dream I ever had yet in my life. The deadliest came out into the room under a door. It rose up like a Cobra—with horrible round eyes and had woman's, or at least Medusa's, breasts. It was coming after me, out of one room, like our back drawing room at Herne Hill, into another; but I got some pieces of marble off a table and threw at it, and that cowed it and it went back; but another small one fastened on to my neck like a leech, and nothing would pull it off. I believe that

most part of it was from taking a biscuit and glass of sherry for lunch, and partly mental evil taking that form.[16]

In 1886 he dreamt that he found the dead body of a child in a box, "a little girl whom I had put living into it and forgotten." Another, the ghastliest nightmare of his life, he describes thus:

After some pleasant, or at least natural dreaming about receiving people in a large house, I went to *rest* myself in a room full of fine old pictures; the first of which, when I examined it—and it was large—was of an old surgeon dying by dissecting himself! It was worse than dissecting—*tearing*: and with circumstances of horror about the treatment of the head into which I will not enter.

Very singular, this coming after a time of singularly (for me) resolute and successful effort, since last Sunday and Monday, to keep myself pure in thought and active in kindness. . . .[17]

What, one would like to know, were the impure thoughts or possible unkindnesses which Ruskin connects with this apalling dream?

There is something treacherous about such dreaming, it represents so completely the tendency which he thought most vicious in art, he who thought Géricault's *Raft of the Medusa* repulsive and Goya fit only to be burned, who was made positively ill by the last act of M. Meilhac's *Frou-Frou*, objected to the tragedies of George Eliot and loved happy endings, sweetness, light and innocence. What business had his sleeping mind to come forth and say, in effect, you, Ruskin, have conceived something far worse than *Professor Tulp* or the "unclean horror

and impious melancholy of the Modern French School."

And yet, if we look back far enough we discover that such macabre imaginings could, like his latent cruelty and arrogance, escape on to paper. Inspired partly by Herodotus and partly by the loss of Adèle, Ruskin as a boy could write in this vein:

> Full through the neck my sabre crashes—
> The black blood burst beneath their lashes
> In the strained sickness of their turning.
> By my bridle-rein did I hang the head,
> And I spurred my horse through the quick and dead,
> Till his hoofs and hair dropped thick and fresh
> From the black morass of gore and flesh.
> > Ha-Hurrah![18]

"I know it was horrible," he explained to W. H. Harrison. "It ought to be so. The man is seeking for something more horrible than his own thoughts. I am glad it makes you shudder. I worked it up on purpose until I had almost sickened myself, and then I was satisfied. It is altogether Scythian—the Scythians wouldn't do for society these days, but if I bring them forward at all they must be Scythians."

Perhaps it was Ruskin's unconscious awareness of the Scythians within him that made him in all the transactions of everyday life so gentle and so tender-hearted. With his pen he made enemies but in conversation he conquered and was conquered by them. Darwin, Gladstone, the Birmingham manufacturers— all his *bêtes noires* became his friends when once they had met him, in all the main efforts and pronouncements of his life he was gentle, generous and humane. If his Scythian had not been there as a

hidden guest his host might have been dull, and, as an artist, Ruskin probably owes him a great deal.

REFERENCES

1. James, *The Order of Release* (1947), p. 220.
2. Whitehouse, *Vindication of John Ruskin* (1950), p. 15.
3. James, *The Order of Release*, p. 138.
4. *Ibid*, p. 145.
5. Whitehouse, *Vindication of John Ruskin*, p. 15.
6. James, *The order of Release*, p. 220.
7. Whitehouse, *Vindication of John Ruskin*, p.15.
8. Leon, *Ruskin the Great Victorian* (1949), p. 197.
9. *F.C.* [letter 67] XXVIII. 645.
10. *P.*, XXV. 25.
11. *F.C.*, [letter 88], XXIX. 388.
12. *Inaugural Lecture* XX. 41, 42.
13. *F.C.*, [letter 41] XXVIII. 81.
14. R. Unwin (ed.), *The Gulf of the Years* (1953) p. 67.
15. *Academy Notes* 1859, XIV. 215–16.
16. *The Diaries of John Ruskin*, ed. Evans and Whitehouse (1956–59), Vol. II, p. 685.
17. *Ibid*, Vol. III, pp. 1099, 878.
18. *A Scythian Banquet Song* II.67.

Chapter 8

VALUATIONS

Ruskin was the first Englishman to make of art criticism a major prose form. Hazlitt and Thackeray had written pleasantly and sensibly enough of art, but for them painting is but one of many subjects: for Ruskin it is the main theme *within* which he can discuss the duty and destiny of man, the evidences and attributes of God. During the greater part of his lifetime Ruskin had no serious rival; the art journalists of the period are forgotten while the Eastlakes and Jamesons and Merrifields are valued only by specialists. Not until Ruskin's powers were declining did Walter Pater produce work that could in any way be compared with his. Our grandfathers turned to Ruskin in matters of art as we turn to the A.B.C. in search of a train. Whistler, it is true, dissented, but Whistler's real quarrel was, not with Ruskin, but with the whole of art criticism.

Two contemporary critics of Ruskin should be noticed. C. R. Leslie, the biographer of Constable, produced in his *Handbook for Young Painters* a very quiet, rational and convincing reply to the first volume of *Modern Painters*. Using Ruskin's own methods of analysis he demonstrates the truth of the older masters such as Claude, Poussin and Canaletto and with moderate but forceful arguments defends the art of Constable. Few people read Leslie's excellent little book today, but still fewer would quarrel with his arguments.

The other contemporary critic who must be noticed is Henry James and his criticism is more

serious, or at least more radical.

"The wreck of Florence," says Mr. Ruskin, "is now too ghastly and heartbreaking to any soul that remembers the days of old"—and these desperate words are an allusion to the fact that the little square in front of the Cathedral, at the foot of Giotto's tower, with the grand Baptistery on the other side, is now the resort of a number of hackney-coaches and omnibuses.[1]

There is a quiet and smiling malice about these words which brings the admirer of Ruskin to a breathlessly indignant halt. The splendidly enraged prophet suddenly becomes a fretful old gentleman in a pother about a cab-stand. It is dreadful to find that Ruskin can be so neatly and abruptly deflated and, as one hurries to the scene with pumps and rubber solution, assuring the reader that James has caught Ruskin in his most petulant mood, and that after all Ruskin was right to be agonised, even unreasonably agonised, by the vandalism of his age—particularly when we consider what we have done in ours—while we are saying all this we must also allow that here is a criticism that ought to be considered.

Throughout the whole of Ruskin's work, it is assumed that art is not only a serious matter, but a matter so deadly serious that it allows no room for doubt or difference and very little scope for wit or delectation.

as for Mr. Ruskin's world's being a place—his world of art—where we may take life easily, woe to the luckless mortal who enters it with any such disposition. Instead of a garden of delight he finds a sort of assize court in perpetual session.[2]

The art of taking life easily was one that Ruskin never mastered and one which—except perhaps in writing *Præterita*—he had no wish to acquire. In art criticism it may well seem that to be at ease is to be insensible; the *flâneur*, the dilettante and the amateur are at ease and seek only delight without commitment, but such a view fails to allow for the fact that impartial observation is not necessarily superficial, that a passionate delight in phenomena may be compatible with a complete indifference to those moral and aesthetic considerations which seemed to Ruskin essential to the artist. Henry James is in fact voicing the opinions of all those artists—the silent and unconscious antagonists of Ruskin—who inherited the realist methods of Gustave Courbet. It was these, the Impressionists and the followers of Degas, who— far more than the art critics—undermined the teaching of Ruskin at the beginning of this century. To such painters an omnibus stationed at the foot of Giotto's tower would have been not a source of vexation, rather it would have been an embellishment, a relief from the too "artistic" aspect of Florence. And where Ruskin would have set his easel at that point which would give him every possible addition of romantic charm, Pissarro or Monet would very likely have allowed the omnibus, its seedy screws, its dowdy, crumpled passengers, its litter of straw and horse dung, glaring posters and miscellaneous luggage to engross the scene.

By the beginning of the twentieth century the battle of Impressionism was won and Ruskin had been not so much contradicted, as made irrelevant. Roger Fry, Ruskin's only rival in power and stature, never made any grand attack on his predecessor. As a young man he read Ruskin, then, going to Italy,

found, as each generation does, a new meaning in the old masters; on his return he in effect rejected, but in practice disregarded the author of *Modern Painters*. Sickert, perhaps because he enjoyed disagreeing with Fry, defended Ruskin, but in fact Fry, with his social view of art and his love of the Italians, was much closer to the nineteenth-century critic. It was left to Geoffrey Scott, in *The Architecture of Humanism*, to mount a full scale attack upon *The Stones of Venice* and, in effect, to come to the rescue of Palladio and the Baroque, although even here the practice of architects anticipated the theory of critics.

If Ruskin's art teaching had, by the second decade of the twentieth century, become irrelevant so far as the *avant-garde* in England was concerned, it is by no means the case that his influence was at an end. His immediate heirs were in the second generation of Pre-Raphaelites—Morris and Burne-Jones. It was, above all, Morris who gave a new and more feasible shape to Ruskin's social and artistic theories. Like Ruskin he was morally distressed and aesthetically disgusted by the Industrial Revolution. But in Morris the dislike of the machine stemmed from a less fundamental and personal aversion. In his writings we can detect a first hesitant attempt to come to terms with modernity, an understanding that the industrial system could not be exorcised but must be tamed. Although the Arts and Crafts movement of the eighteen-eighties and -nineties was a decidedly Ruskinian affair and showed little appreciation of industrial realities there emerged from it, first in England with C. R. Ashbee and later in Germany and the Low Countries with Vandervelde and Muthesius, an artistic movement in which modern technology

was at last brought fully into harmony with Ruskinian ideas and from this grew the Bauhaus, the wayward, perhaps disrespectful, but still legitimate grandchild of *The Stones of Venice*.

While Europe east of the Rhine took Ruskinian ideas and used them to create a new form of art and art education, in France Ruskin, despite the interest in his work shown by the Neo-Impressionists, was above all a literary influence. Already, during Ruskin's lifetime, he attracted the attention of M. Milsand and was translated by Ernest Chesneau: in the years when he was much neglected in England he became the subject of numerous studies in France. The purely aesthetic side of his teaching was expounded by M. de la Sizeranne; MM. Chevrillon, Bardoux and Guillon examined his religious and social message, finding in it a grateful alternative to continental atheism and socialism. His affinity with Bergson was also noticed and has formed the subject of interesting studies by Mlle. Henriette Gally and M. Floris Delattre; his profound influence upon Marcel Proust has been discussed by M. André Maurois and—with great exactitude—by M. Jean Autret.

In the United States Ruskin has been of particular interest to the historian of ideas and three works deal with the development of his aesthetic: Mr Henry Ladd's *Victorian Morality of Art*, Mr Francis Townsend's *Ruskin and the Landscape Feeling* and Mr Buckley's *Victorian Temper* deserve careful study. Mr Buckley, in one short lucid chapter, says more than many of the more long-winded critics of Ruskin.

In England, between the time of his death and the revival of interest which began with Mr Wilenski's "introduction" of 1933, Ruskin's influence, so far as it existed, was political.

It has frequently been said that in 1906, when the Labour Party first emerged as a political power, it was found that the book which had exerted the greatest influence on the members of this young party was *Unto this Last*. I have questioned a veteran of the movement who doubts whether any of them had in fact read it. Perhaps they had not: but the mere fact that they felt that they ought to have done so is significant. Ruskin, before his death, had been canonised. Ruskin was culture and British socialism in its youth was respectful of educated opinion; it is easy enough to find the influence of Ruskin in socialists such as Morris and Crane, but it will be found also in the early prefaces of Bernard Shaw and in the works of Tawney and Eric Gill. Moreover, Ruskin was already so much a figure of the past that he did not have to be accepted plank by plank like a political platform; one might omit that which was unpalatable. And then he was so very religious, which to the members of a movement which derived its strength not from scientific materialism but from lay preachers, was reassuring. By the twentieth century, therefore, Ruskin, even though he might remain largely unread, could be accommodated in the Pantheon of British social democracy. Whether he still has a place there may well be doubted. Of his influence abroad I know too little to speak; no doubt he was acceptable to the Tolstoyans and he appears to have had a great effect upon the young Ghandi.

Ruskinians have often claimed Ruskin for their own purposes. Mr Frederick Harrison declares that he is really a Positivist, Mr John Graham puts him among the Quakers, Mrs Meynell does her best to bring him into the fold of orthodox Christianity, Mr J. A. Hobson presents him as a gradualist reformer,

147

M. Signac claims him as a Neo-Impressionist, Dean Farrar as a patriotic Christian, Sister Mary O'Brien nominates him for the "personalist" movement of Dr Paul Hanley Furley. So far as I know, the Marxists have never claimed him, although several writers have pointed out that the nearest equivalent to his brand of authoritarian socialism is to be found in the Soviet Union. Such claims and the efforts to trace his influence in this or that political or artistic movement may be historically or intellectually amusing, but for the student who comes new to the works of Ruskin the important question is: how can he best be enjoyed?

Perhaps one may answer by telling the reader what *not* to expect. Nowhere, not even in *Prœterita*, will he find a perfectly simple tale or an argument expressed with perfect lucidity; he must be prepared, like Alice through the Looking-Glass, to turn his back upon his destination before he can reach it. He must keep his temper and his historical perspective, he must learn to accept so that presently he may rejoice in Ruskin's faults, foibles and inconsistencies. Finally, he must learn to love the florid rhetorical prose of Ruskin's earlier manner, for it is in this—the ability to match great painting with language no less great— that Ruskin's achievement lies. He was the first art critic to create one masterpiece in praising another.

Finally, I may perhaps liken the works of Ruskin to an enormously extensive forest, a forest that displays all the grandeur, the asperity and the abundant variety of its creator, now raised by the ascendant majesty of the hills, now depressed to contain the fretful fury of flowing rivulets or the placid reflective waters of tree-girt lakes. Here you may find bleak woods, ghostly and barely habitable, but here too

are pleasant shades and fruitful avenues, pure blossom
and goodly fruits. Here is a carpet to make it soft to
the traveller, a coloured fantasy of embroidery
thereon, then full spreading foliage to shade him from
the sun's heat. Stout wood to bear this leafage and,
when the leafage falls away to let the sun warm the
earth, seeds made beautiful and palatable, cold juice
or growing spice or balm, or incense, softening oil,
preserving resin, medicine or styptic febrifuge of
lulling charm. If there are also some darker, sterner
places, tortuous paths flanked by sword-sharp leaves,
venomous insects and reptiles, sudden obstructive
boulders and foul, dreary, miasmic, leech-infested
swamps we should not for that reason meekly abandon
so proud a venture and to those who will set forth I
wish a prosperous journey.

In this paragraph the intelligent reader will at once
be able to distinguish those passages which are cribbed
from the fifth volume of *Modern Painters*.[3]

REFERENCES

1. Henry James, *Italian Hours*. 3. *M.P.*, [Vol. 5.] VII. 13—16.
2. *Op. cit.*

SELECT BIBLIOGRAPHY

There is a very complete bibliography in VOL. XXXVII of the "Library Edition". Useful select bibliographies will be found in the works by Derrick Leon, Dr Joan Evans and John D. Rosenberg listed below.

I. RUSKIN

The Works of John Ruskin, ed. E. T. Cook and Alexander Wedderburn, 39 vols. 'Library Edition'. London (George Allen) 1903–1912.

The Diaries of John Ruskin, ed. by Joan Evans and J. H. Whitehouse. 3 vols. Oxford (Oxford University Press) 1956–1959.

Ruskin's letters from Venice, 1851–1852, ed. John Lewis Bradley. Yale (Yale University Press) 1955.

II. OTHERS

ASHBEE, C. R.: *An endeavour towards the teaching of John Ruskin and William Morris*. London 1901.

AUTRET, J.: *L'influence de Ruskin sur la vie, les idées et l'oeuvre de Marcel Proust*. Geneva 1955.

BENSON, A. C.: *Ruskin, a study in Personality*. London 1911.

BUCKLEY, J. H.: "The Moral Aesthetic," in *The Victorian Temper*. Harvard 1951.

BURNE-JONES, MRS: *Memorials of Edward Burne-Jones*. London 1904.

CLARK, SIR KENNETH: *Præterita*, introduction by Sir Kenneth Clark. London 1949.

——: *Ruskin at Oxford*. Oxford 1947.

SELECT BIBLIOGRAPHY

COLLINGWOOD, W. G.: *The Art Teaching of John Ruskin*. London 1891.

——: *The Life and Work of John Ruskin*. London 1893.

COOK, E. T.: *The Life of John Ruskin*. London 1911.

DELATTRE, FLORIS: *Ruskin et Bergson*. Oxford 1947.

EVANS, J.: *John Ruskin*. London 1954.

FAIN, J. T.: *Ruskin and the Economists*. Nashville, Tennessee 1956.

GALLY, H.: *Ruskin et l'esthétique intuitive*. Paris 1933.

GOETZ, M. D.: *A study of Ruskin's concept of the Imagination*. Washington 1947.

GRAHAM, J. W.: *The Harvest of Ruskin*. London 1920.

HARRISON, F.: *John Ruskin*. London 1907.

HOBSON, J. A.: *John Ruskin, Social Reformer*. London 1898.

HOUGH, G.: "Ruskin," in *The Last Romantics*. London 1949.

JAMES, W. M.: *The Order of Release*. London 1947.

LADD, H.: *The Victorian Morality of Art*. New York 1932.

LEON, D.: *Ruskin the Great Victorian*. London. 1949.

MACDONALD, G.: *Reminiscences of a Specialist*. London 1932.

MAUROIS, A.: "Proust et Ruskin," in *Essays and Studies by members of the English Association*. London 1931.

MEYNELL, A.: *John Ruskin*. London 1910.

PAINTER, G.: "Salvation through Ruskin," in *Proust: the Early Years*. London 1959.

PROUST, M.: *Pastiches et mélanges*. Paris 1927.

QUENNELL, P.: *John Ruskin, the Portrait of a Prophet*. London 1949.

RITCHIE, ANNE: *Records of Tennyson, Ruskin and Browning*. London 1892.

ROSENBERG, JOHN D.: *The Darkening Glass*. Columbia 1961.

SHAW, G.B.: *Ruskin's Politics*. London 1919.

SIZERANNE, R. DE LA: *Ruskin et la religion de la beauté*. Paris 1897.

SPIELMANN, M. H.: *Ruskin*. 1900.

STEPHEN, L. : "John Ruskin," in *Studies of a Biographer*. London 1902.

UNWIN, R.: (Ed.) *The Gulf of the Years* [Letters to Kate Olander]. London 1953.

WHISTLER, J.: *The Gentle Art of Making Enemies*. London 1890.

WHITEHOUSE, J. H.: *Ruskin Centenary Addresses*. Oxford 1919.

——: *Vindication of John Ruskin*. 1950.

WILENSKI, R. H.: *John Ruskin, An introduction to the further Study of his Life and Works*. London 1933.

WILLIAMS-ELLIS, A.: *The Tragedy of John Ruskin*. London 1928.

WOOLF, V.: "Ruskin," in *The Captain's Deathbed*. London 1950.

Since this book was first published a number of contributions to Ruskin scholarship have appeared. The following list is by no means exhaustive.

The Ruskin Newsletter, published by the Ruskin Association at Bembridge School, Isle of Weight, ed. by J. S. Dearden, provides a running commentary

on all publications concerned with Ruskin.
The following collections of letters and diaries, mostly unpublished:

BRADLEY, J. L.: (Ed.) *The Letters of John Ruskin to Lord and Lady Mount Temple*. Columbus, Ohio 1964.

BURD, Van Akin: (Ed.) *The Ruskin Family Letters: The Correspondence of John James Ruskin, His Wife & Their Son, John, 1801–1843*. 2 vols. Ithaca, New York 1973.

——: (Ed.) *The Winnington Letters: John Ruskin's Correspondence with Margaret Alexis Bell & The Children at Winnington Hall*. London 1969.

SURTEES, VIRGINIA: (Ed.) *Sublime and Instructive: Letters, 1855–64*. London 1972.

VILJOEN, HELEN G.: (Ed.) *The Brantwood Diary of John Ruskin Together with Selected Related Letters & Sketches of Persons Mentioned*. New Haven, Connecticut 1971.

ANTHOLOGIES

CLARK, KENNETH: (Ed.) *Ruskin Today*. London 1964.

LUTYENS, MARY: *Effie in Venice*. London 1965.
——: *Millais and the Ruskins*. London 1967.
——: *The Ruskins and the Grays*. London 1972.

ROSENBERG, JOHN D.: *The Darkening Glass: Ruskin's Genius*. London 1963 (reissue).

——: (Ed.) *The Genius of John Ruskin*. London 1964.

BIBLIOGRAPHY

K. H. BEETZ: *John Ruskin, a bibliography 1900–1974*. Scarecrow Press Inc., Metuchen, New Jersey.

INDEX OF THE NAMES OF
PLACES AND OF PEOPLE

I have used the following abbreviations:
R = Ruskin
m = mentioned
fict = fictitious place or person
works of art follow, where possible,
the names of their authors and are
printed in italics.

INDEX

INDEX

INDEX

MICHELANGELO, base yet noble, 79, boldly animal, 80, majestic, 93, corrupts, 100—1, carnal, 101—2, rhetorical, 102, 103, why disquieting to R. 104, m, 21, 104, 107, 135
—, *Last Judgment*, 102, 104
MILAN, 36
MILLAIS, Sir J.E., marries Mrs Ruskin, 41, and R's ideas, 49, friendship with, 51, innocence 132, m, 126
—, *Carpenter's Shop*, 49
—, *Mariana*, 49, 50
—, *Spring*, 136
MILLAIS, Lady, *née* EUPHEMIA ('Effie') GRAY, sometime Mrs R., *King of the Golden River* written for, 40, marriage, 40—1, revenged, 84, R. on, 128-9, her version, 130, ill-treated, 131, R's pupil, 136, m, 83, 124, 137
MILL, J.S., 63
MILNER, Lord Alfred, 99
MILSAND, J., 146
MILTON, 77, 92
MINEHEAD, 54
MONET, 144
MORE, Sir T., 73
Morning Post, 66
MORRIS, W., 114, 145, 147
MUTHESIUS, 145

NAPOLEON III, 72
NATIONAL GALLERY, 24, 116
NIMES, 36
NORRIS, Mrs (fict), 123
NORTON, C.E., 124, 135

O'BRIEN, Sister Mary, 148
Old Testament, 78
OLANDER, Kathleen, picked up by R. 116, letters intercepted, 117, published, 128, R's manner with, 136
OXFORD, R. and family at, 19, removed from, 20, science museum at, 68, drawing school, 87, Slade Professor at, 98, Hinksey Road, 99, eccentric behaviour at, 100, 104—5, m, 91, 115

PAESTUM, 36
PALLADIO, 35, 145
PATER, W., 142
PATMORE, Coventry, 49
PERUGINO, 107
PISA, 36, 37
PISSARRO, 144
POPE, A., 23
POUSSIN, Gaspard, 24, 26
—, *Aricia* or *La Riccia*, 24—6
POUSSIN, Nicolas, blamed for painting tufa, 55, defended, 142, m, 34, 104

159

INDEX

INDEX